WILDLIFE PHOTOGRAPHY

Advanced Field Techniques for Tracking Elusive Animals and Capturing Magical Moments

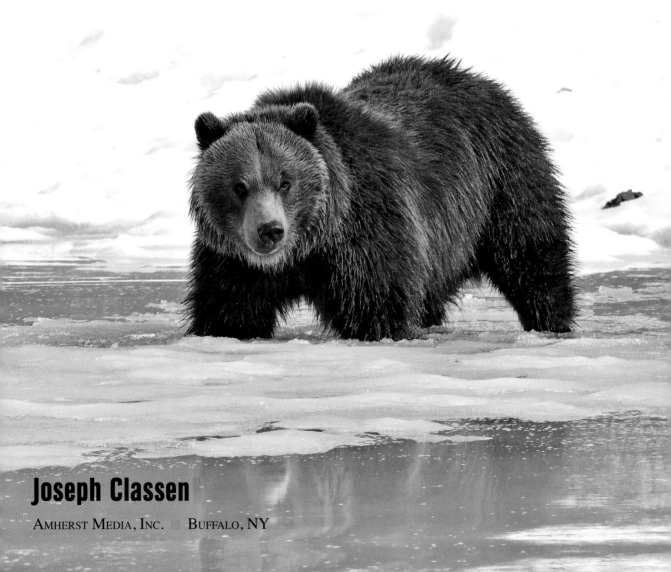

Joseph Classen

AMHERST MEDIA, INC. BUFFALO, NY

Dedication

To my beautiful Patricia. Thank you for filling my life with peace, joy, and love. You are the treasure of my heart, always and forever!

Published by:
Amherst Media, Inc., P.O. Box 586, Buffalo, N.Y. 14226, Fax: 716-874-4508
www.AmherstMedia.com

Publisher: Craig Alesse
Senior Editor/Production Manager: Michelle Perkins
Editors: Barbara A. Lynch-Johnt, Harvey Goldstein, Beth Alesse
Associate Publisher: Kate Neaverth
Editorial Assistance from: Carey A. Miller, Sally Jarzab, John S. Loder
Business Manager: Adam Richards
Warehouse and Fulfillment Manager: Roger Singo

ISBN-13: 978-1-60895-913-6
Library of Congress Control Number: 2015931597
Printed in The United States of America.
10 9 8 7 6 5 4 3 2 1

www.facebook.com/AmherstMediaInc
www.youtube.com/c/AmherstMedia
www.twitter.com/AmherstMedia

Contents

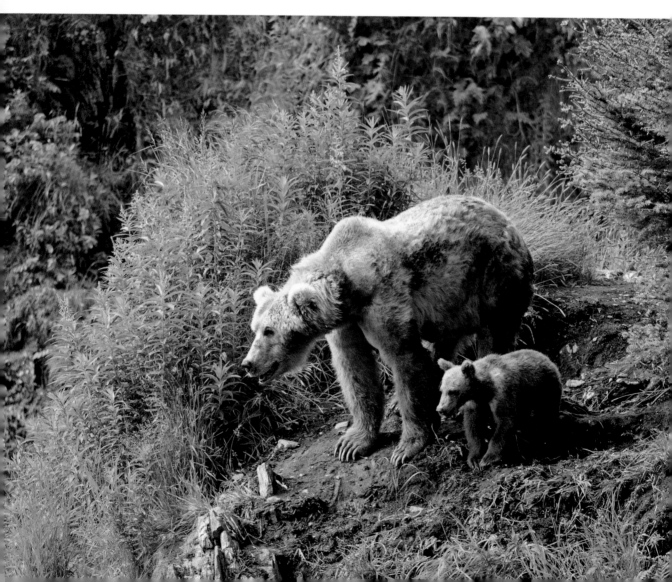

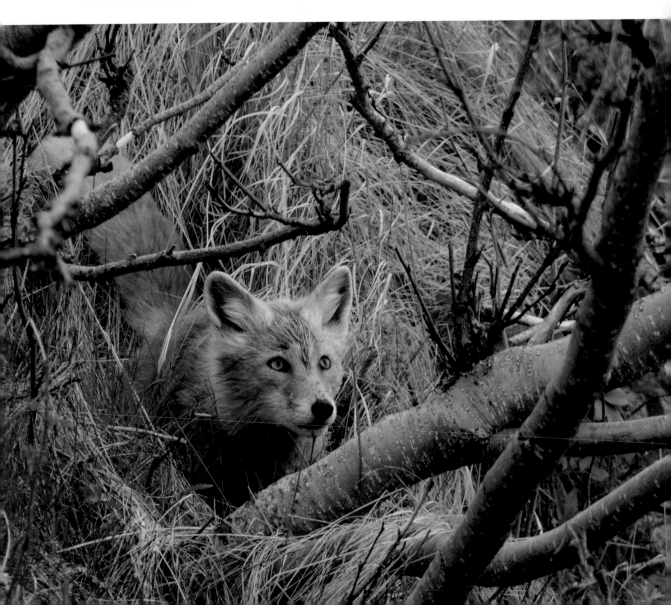

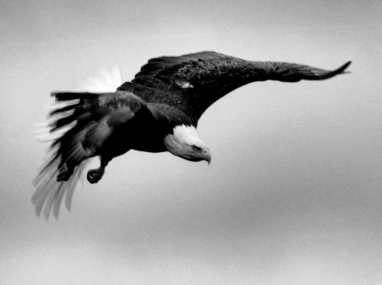

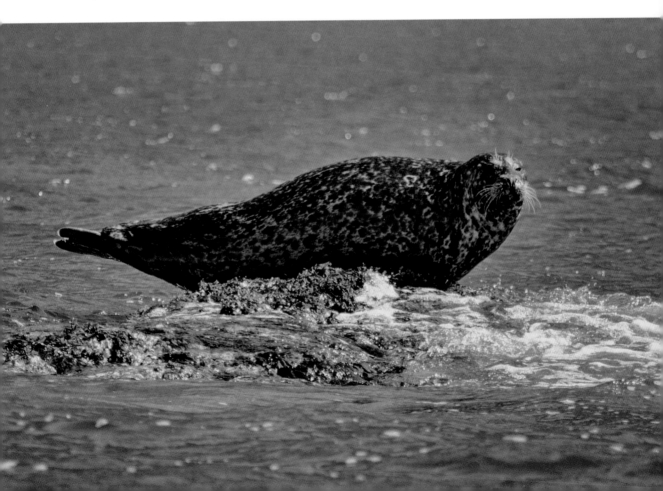

Foreword

Wildlife photography is an excellent way to see natural wonders from a whole new perspective. Once you embark on this journey, you begin to experience subtleties in detail, lighting, composition, and form that casual observers overlook. Wildlife photography also tests your patience and draws you into new places and new weather conditions that few experience as you enter into the world of your subject in an effort to get that perfect shot. You also have unique opportunities to learn intimate details of animal behavior and habitats.

Along with these new experiences come new responsibilities because you are a guest in the animals' homes and your actions can impact their survival. Even though the culmination of stalking and shooting animals with a camera is a photographic image, not the meat, hide, or antlers, if done incorrectly wildlife photography can be even more damaging to wildlife populations than closely regulated hunting. The challenge is to learn how to capture your image with little or no change to the animals' lives and share that image with others so that they too can appreciate the wonder and fragility of our exquisite planet and the varied inhabitants we share it with.

Joe Classen is a well-recognized expert in wildlife photography, outdoor living, and philosophy. He has learned how to achieve that elusive balance of capturing the essence of the animals and their habitats in an honest, respectful, and entrancing way. In this book, he generously shares some of his techniques with you. While his tips will not make your trips any shorter, warmer, or drier (in fact, they may make them less comfortable!), I can promise you that they will make them more satisfying as you learn more about your subjects, impact them less, and end up with better images than ever before.

Larry Van Daele, Ph.D.
South-Central Regional Supervisor
Division of Wildlife Conservation
Alaska Department of Fish and Game

Introduction

It happens every morning. From an abyss of blackness, a slight glow emerges on the horizon. As the glow intensifies, the silhouettes of clouds appear and slowly become backlit in the expanding light. Shades of primary colors begin to gently brew and blend in the eastern atmosphere. Meanwhile, ever so subtly, the landscape below begins to take shape in the ever-growing illumination of the dawning day. Outlines and evolving distinctions lethargically develop out of the darkness. As the horizon continues to brighten, the surrounding skies begin to absorb the light and reflect it down upon the land, giving it greater clarity and definition with every passing moment.

While the clouds on the horizon remain silhouetted and dark, the atmosphere behind them becomes increasingly brighter. In the east, an epicenter of intense color begins to exert dominance in the sky. A fire slowly burns and impregnates the surrounding clouds with hues of orange and red. A soft pink and yellow glow begins to overtake the horizon and gently

▼ For a nature photographer, there is nothing as glorious and filled with promise as the dawning of a new day!

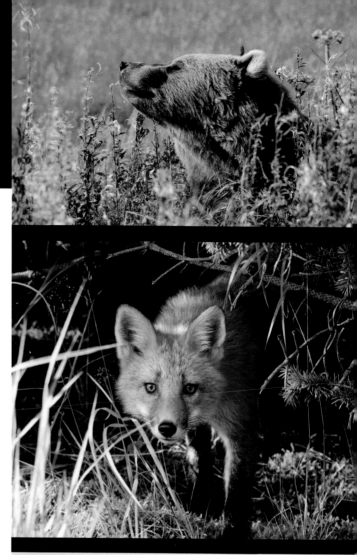

▶ **Top:** A Kodiak brown bear basks in the sunshine, after a week of cold, rainy weather.

▶ **Center:** A beautiful red fox cautiously steps out of the brush to begin an evening hunt.

▶ **Bottom:** A curious bull moose hits a priceless pose.

evolves into a vastness that blankets the heavens. As the pink and yellow light transforms into red and orange, the outlines of surrounding mountains begin to separate themselves from the clouds along the skyline. Meanwhile, the still waters below reflect a mirror image of what is above, creating a perfect, earthly harmony.

As the clarity, exposure, and saturation of natural light and color are increased with every second of passing time, the grand finale of earthly awaking rather suddenly reaches a climax and erupts from the stoic stillness of the morning prelude. From the burning eastern epicenter on the horizon, the great universal source of light and heat begins to take a peek upon the land. As the sun fully reveals itself and rises above all of creation, the backlit clouds become a soft blue, and all the colors of the morning masterpiece explode into magnificence and give birth to the new life of day.

And then, the long-awaited moment finally comes. As all of creation begins to come to life and basks in the morning sun, a magnificent creature emerges before you; it simply materializes out of the shadows and evaporating mist. The excitement and privilege of witnessing such an overwhelmingly beautiful, hidden moment makes the heart beat wildly. It's just you and your camera that can immortalize and share such a rare experience. Much of humanity will never witness anything like this

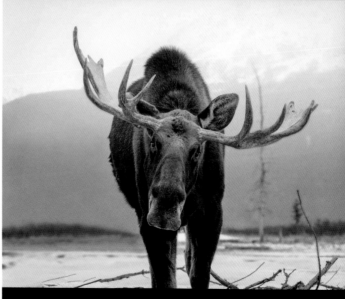

moment—a moment that is genuinely priceless, a moment that will be cherished for a lifetime and beyond. This is the moment a wildlife photographer lives for. This is the moment I hope to prepare you for by means of this book.

A Little About Me

Let me take this opportunity to officially introduce myself to you. My name is Joseph Classen, and I am originally from St. Charles, Missouri. Located along the Missouri river, and nearby the mighty Mississippi, this historic town was founded in 1769 by Louis Blanchette and was known as a launching pad for early explorers, traders, and immigrants who were heading west. St. Charles was a thriving trading community back in the day; it was the site of the famous Lewis and Clark Rendezvous, and it was also the familiar stomping grounds of individuals such as Daniel Boone. It was along those muddy rivers, immersed in that adventurous, pioneer spirit that my undying love of the outdoors was born.

Throughout my entire life, from my earliest memories as a child, up until this very day, a passionate love of the natural world has possessed my soul. There has never been a time that my heart didn't begin to beat faster at the very thought of heading outdoors for an adventure of one kind or another, no matter how big or small. My infatuation with Mother Nature has produced an unquenchable thirst that has taken me to some of the wildest, most unforgiving, and remote locations in the United States and Canada. In fact, that "call of the wild" certainly played a part in bringing me to the place I currently call home: Kodiak Island, Alaska, one of the most beautiful and rugged places in the world.

Over the last decade or so, I've shared my experiences and love of nature through various forms of media. I've written numerous books and articles on a variety of nature-related topics; I was the host of a nationally syndicated outdoors-themed radio show for several years; I'm a member of the Professional Outdoor Media Association; and I also work as an Alaskan photography, fishing, and wilderness guide. Please visit my website Wild Revelation (www.wildrevelation.com) for more information. My photography work has won awards, been published in numerous magazines, featured by conservation organizations and travel bureaus, and it continues to gain worldwide exposure.

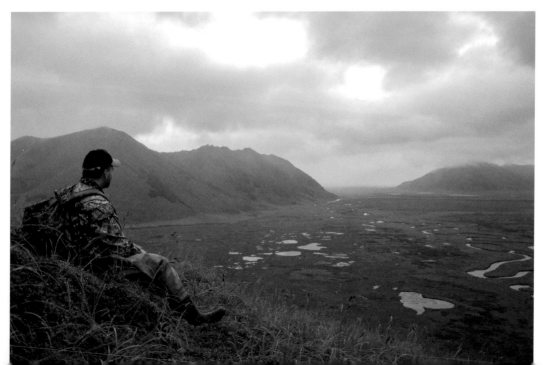

◀ The author surveying a vast wilderness of photographic opportunities.

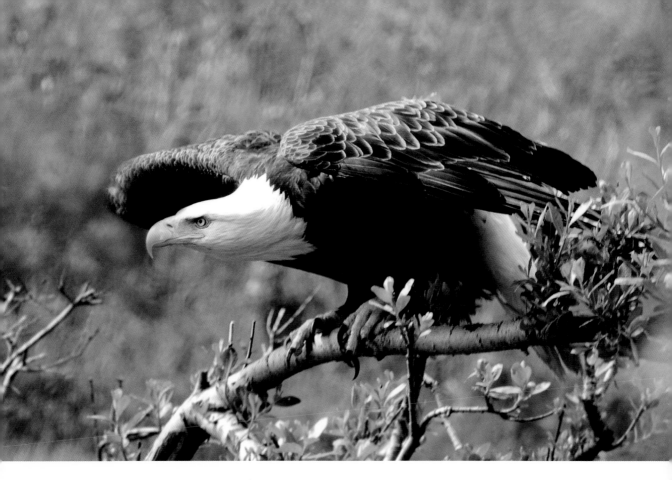

From Hunter to Photographer

▲ A bald eagle prepares for take-off.

While there are few things I enjoy more than exploring and sharing unique experiences of wild nature and wildlife through photography, I actually became a nature and wildlife photographer through sort of an evolution from other outdoor activities. The vast majority of my time spent in the outdoors over the years has been primarily as a fisherman and hunter. I began fishing literally before I can even remember, and my role as a hunter began as soon as I was strong enough, educated enough, and responsible enough to become an active participant in nature's cycle of life. This, in essence, is what hunting is all about. I've successfully pursued everything from the gargantuan moose and elk that inhabit Alaska and the Pacific Northwest, the whitetail deer and turkey of the Midwest, down to the wild hogs that ravage the lands of the southern states.

The Cycle of Life

There is a fair amount of controversy today about the subject of hunting, and while much of the focus of this book is on the skills, principles, and techniques learned through hunting, my intention is not to dwell or preach on the ethics of that purist. However, I do feel it necessary to say at least a few things on the topic throughout these pages, as wildlife photography is, quite literally, a matter of hunting with a camera. There are many similarities between the two pursuits, as we will see.

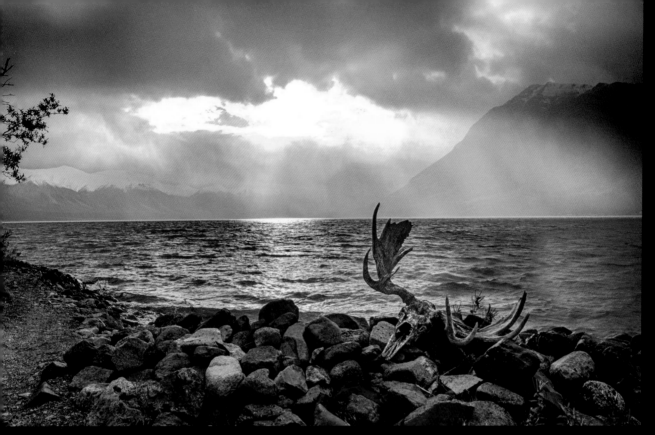

▲ The cycle of life is evident everywhere in nature. The wilderness is not Disneyland.

◄ The reality of the struggle for survival creates many interesting photo opportunities. Here, an ermine feasts on a fox carcass.

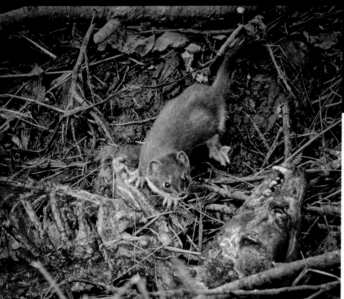

First of all, speaking personally, if I did not fish and hunt, I'd either be dead broke or just plain dead. In places like Kodiak Island, Alaska, the vast majority of our fresh fruit, vegetables, milk, and other staples of basic nutrition have to be shipped in, resulting in extremely high costs to the consumer. For those who do not have money to burn, if they do not find alternative, cost-effective methods of filling the freezer with quality, essential, high-protein food sources for the year, they will be in big trouble! And in places like Alaska, there is nothing more cost-effective, and truly natural, than providing food through the responsible management and personal harvesting of renewable, natural resources—that is, hunting and fishing. After all, the native Alaskans have done it for centuries and virtually every creature that roams this land, from the tiniest songbird to

the most massive Kodiak bear, spends every day of its life actively seeking out food, which comes as another form of life.

A universal principle of life on planet earth is that something has to die for something else to live. The food chain and the cycle of life are often brutal, undeniable realties in wild nature. A true hunter is one who becomes a responsible, active participant in the actualizing of those primordial principles, and who also knows firsthand the reality of the genuine price that must be paid for a meal, and ultimately, for one's survival.

While fresh, organic, humanely harvested food on the table and in the freezer is certainly the end goal of hunting and fishing, it is a tiny part of the entire experience—at least for me. As I often tell folks, when you add up the countless hours of quality, unforgettable, cherished time that a hunter or fisherman spends literally immersed in the beauty of creation, a grand total of a matter

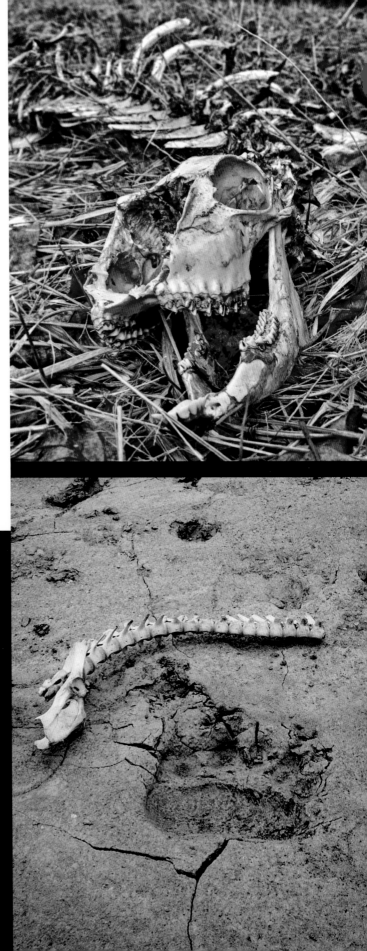

▶ **Top:** Creatures that became food for others are a not-so-beautiful reminder of the price of a meal in the wilderness.

▶ **Bottom:** The remains of a blacktail deer, and the tell-tale track of the huge bear that had it for dinner.

▼ A young bald eagle braves a winter storm to gorge itself on the remains of a humpback whale.

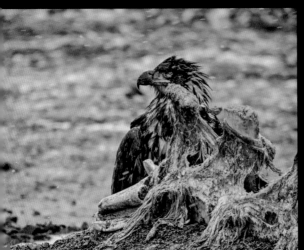

of seconds is spent actually taking the life of something. The rest of that time—all those countless hours and days with all their glorious sunrises and sunsets, with all the sights, sounds, smells, and feelings that much of humanity never experiences—is spent admiring, studying, and actively participating in the primal ways of the natural world. The desire to capture and share such experiences is what gave birth to my love of photography.

A Hunter with a Camera

Many years ago, I began to notice that during my time spent in the field hunting or fishing, I was constantly saying to myself, "Darn! I wish I had a camera! Look at that!" And so, I eventually bought a decent point-and-shoot

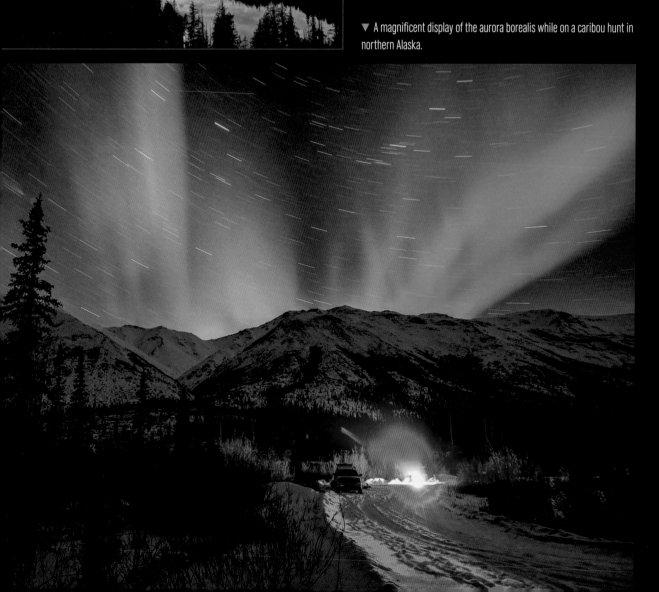

◀ A stunning sunset as seen from a super-remote mountaintop while hunting in the extreme wilderness of southeast Alaska.

▼ A magnificent display of the aurora borealis while on a caribou hunt in northern Alaska.

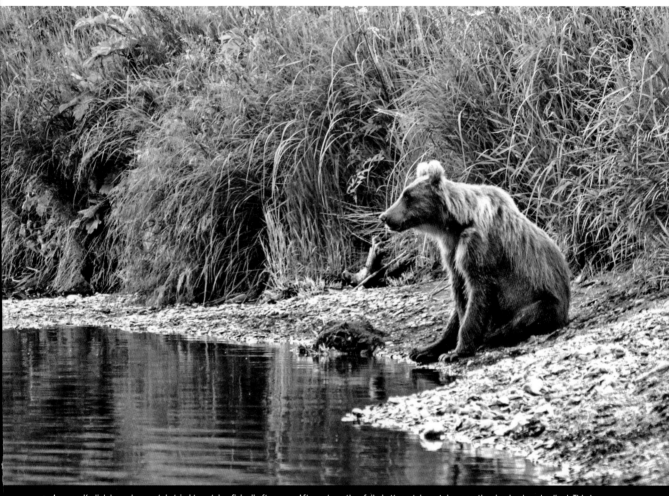

▲ A young Kodiak bear desperately tried to catch a fish all afternoon. After yet another failed attempt, he sat down on the riverbank and sulked. This is an image I captured while fishing.

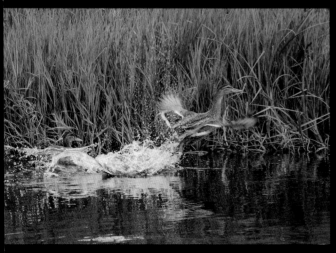

▲ A blue winged teal takes off as the fishing boat I was in was headed his direction.

▲ A sad, humiliated Kodiak bear who was run off by a more dominant bear. I captured this image while out salmon fishing one autumn afternoon.

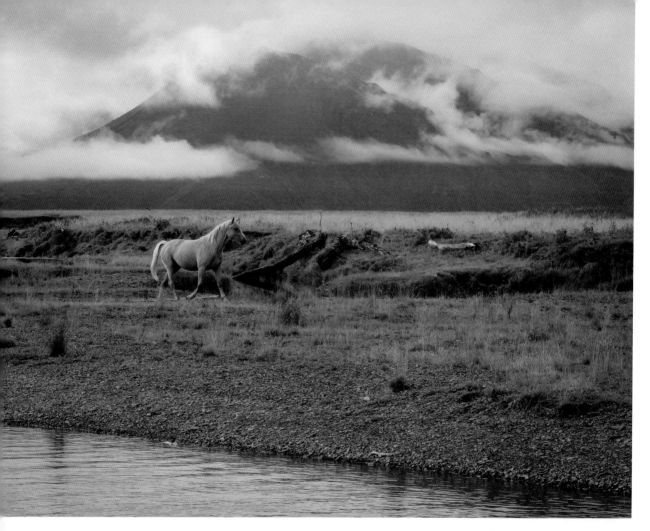

▲ A wild horse magically appeared out of nowhere and crossed the creek downstream from me. Another shot I captured when fishing in the wilds of Kodiak Island.

camera to take with me when I headed to the woods or the waters. I soon began to notice that what started off simply as a means of capturing memorable moments of outdoor adventure eventually began turning into the adventure itself. I found myself spending more and more time seeking out things to capture with my camera instead of my bow or fishing rod. "Catch and release hunting," I began to call it, which one can do year-round. The only downside is that one can't eat photographs and memories! The images on pages 14–17 are a few of my favorites that were captured over the years while on the hunting and fishing adventures that eventually inspired my transition from hunter/fisherman to photographer.

The Purpose of This Book

After that initial, infectious bite of the shutter-bug set in, I developed a major case of photography fever! My passion for nature and wildlife photography exploded! I began to regularly upgrade my camera gear, from point-and-shoot cameras to pro-grade DSLRs, and I continued to learn all I possibly could about the art of photography—from shooting techniques, to processing, to finishing and marketing photographs. While I learned a tremendous amount

about the mechanics and essentials of photography through a variety of books, workshops, etc., I noticed that there was a real absence in addressing some very important matters that applied specifically to more advanced nature and wildlife photography, most especially in the way of preparation and planning for a serious wilderness photo shoot.

Upon further reflection, I began to give serious thought to the notion of writing a book myself to cover these topics more in-depth, which you now have in your hand. After all, not too many photographers out there can honestly say that they've spent entire weeks, from sun up to sun down, thirty feet off the ground in a tiny, uncomfortable tree stand, all the while waiting for, watching, and studying the ways of nature and wildlife. Along the same lines, I'd be willing to bet that not too many photography book authors regularly spend time in places where the only discernible paths through the otherwise impenetrable wilderness are thousand-year-old bear trails, which are still actively traveled by thousand-pound bears. I certainly don't mean to "toot my own horn,"

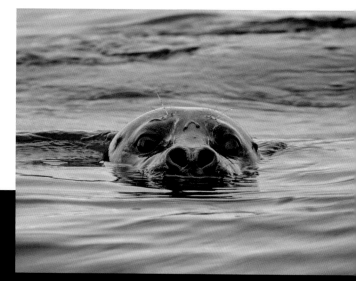

► A stealthy harbor seal was fishing in the same river inlet I was.

▼ A rainbow emerged over the Ayakulik River as I was in search of silver salmon.

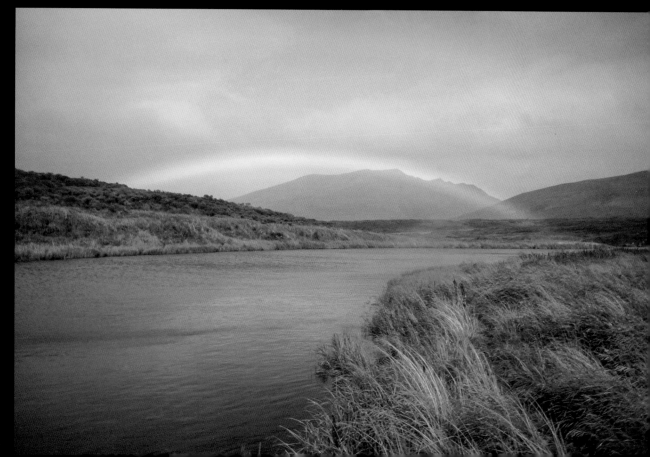

as they say; I simply share this information with you, the reader, to verify my credentials for writing such a book.

Now, let's get down to business. In the grand scheme of things, taking quality photographs, of any subject, is not all that difficult once one invests the time to master their chosen equipment. If you have not done so as of yet, I'd encourage you to stop here, take the time to intimately know your camera, inside and out, get lots of practice with it, and then come back to this book. The information in this book is not so much about how your camera can create great wildlife photos; it's about how *you* can create great wildlife photos through diligent preparation for time in the field and by utilizing certain skills to make the most of the valuable opportunities that present themselves. This book will teach you what it takes to be thoroughly prepared for every aspect of a photographic adventure, and it will give you an understanding of more advanced

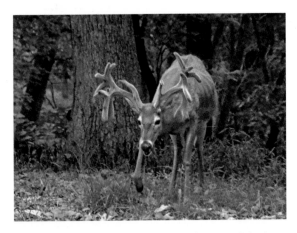

▲ Early in my photography career, I spent an entire summer trying to capture images of this incredible old whitetail buck at a wildlife reserve. When he finally made an appearance, I blew it! As you can see, the photo is noisy, grainy, badly composed, and just looks terrible! This is because I did not learn how to use my camera correctly in low-light situations and simply relied on automatic settings. Learning how to use your camera equipment to its maximum potential is an absolute prerequisite.

techniques, principles, and tools that can ultimately help you capture and create the wildlife photographs of a lifetime.

As the information in this book is intended for those who have a solid, working knowledge of the basics of photography, as well as knowing their particular camera and equipment, I will not be spending much time talking about the technical aspects of digital cameras, photography software, etc. There are lots of great resources out there to learn these things that are an essential prerequisite to more advanced genres of photography. Essentially, my goal is to help you become a successful wildlife photographer by helping you become a successful hunter—using the camera as the instrument of harvest. My mission is to help you become more educated, confident, safe, and respectful while immersed in the wilderness for photography purposes. In doing so, it is my wish that you not only learn to be a better wildlife photographer, but also a more gracious steward of creation and the creatures that we share this world with. And for those who are still in the beginning stages of nature photography, or who just plain enjoy wildlife photos, I hope that this book will simply be a source of inspiration and enjoyment for you.

On a final and very important note, please keep in mind that the information and techniques I'll be covering in this book are those that one could spend a lifetime studying and practicing. That being said, while I will be giving a complete and thorough overview of some essential preparations and skills necessary to become a more advanced wildlife photographer, it is still an overview. It is my hope that you will take the time on your own to do more in-depth study and disciplined practice of what you learn in this book.

1. The Sacred Hunt and the Photographer

For many in our modern, so-called civilized society, "hunting" is a dirty word and an extremely misunderstood activity. Certainly, there are those who have given it a bad name and who have only amplified the misconceptions about the true nature of the hunt even more. In order to truly understand the core value and purpose of hunting, one must go back to its roots.

True Hunting

For the earliest human beings and the native/ aboriginal peoples of our world, hunting was not only a vitally essential way of life in order to provide food, shelter, tools, clothing, etc., but it was elevated to a sacred activity. Prayer, ritual, music, dance, and various art forms all expressed and celebrated the essence of the hunt: the connection with the Creator, respect for the forces of nature, ancestral ties, the passing on of tribal traditions and values, the learning and disciplined exercising of skill, the magnificence of the game animals they pursued, and the gratitude for the earth's bounty.

To become a successful hunter, one began training at an early age. One needed to develop in bodily strength and mental cunning, as well as grow in virtue in order to possess the patience and persistence necessary for the hunt.

It was essential for a young hunter to become intimately familiar with, and extremely knowledgeable of, the animals he was to pursue, as well as the land which those creatures inhabited. Along with that, the hunter had to learn tracking skills, survival, stalking and stealth skills, deadly proficiency with a primitive weapon, ambush techniques, meat processing and preservation skills, cooking skills, etc. The list goes on and on.

> ❝ In order to truly understand the core value and purpose of hunting, one must go back to its roots. ❞

True hunting was not, and has never been, simply a matter of going out and killing a defenseless animal in order to fulfill a depraved bloodlust. Hunting and killing are two very different things. While most people today hunt at the grocery store, very few actually kill their own food. Keep in mind, the end result of many hunts, both ancient and modern, is the hunter coming home empty-handed. When a hunter is seen rejoicing over the carcass of a freshly harvested game animal, it is not because

he is rejoicing over the death of the creature; rather, the hunter is rejoicing because his Herculean effort has paid off. He knows good and well that the animal's death will provide the essentials of life for him and his family. And for this, the hunter's gratitude and respect was elevated to a truly sacred, spiritual level—as is still the case today for those who hunt with the proper intentions.

A similar phenomenon holds true for a dedicated wildlife photographer. Getting photographs of elusive wild animals is certainly not always an easily achieved, done deal. A tremendous amount of patience, preparation, hard work, and sacrifice can go into producing one, single, quality image for which the photographer rejoices and shares with others.

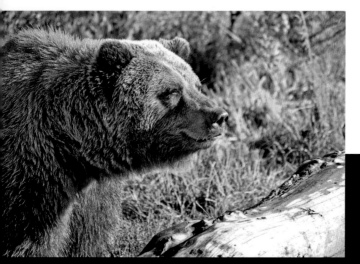

◄ Capturing magical moments, like a smile easing across the face of a brown bear recently out of hibernation, can take great patience.

▼ Waiting for a mother and baby Kodiak bear to hit the same pose together was another occasion of exercising extreme patience.

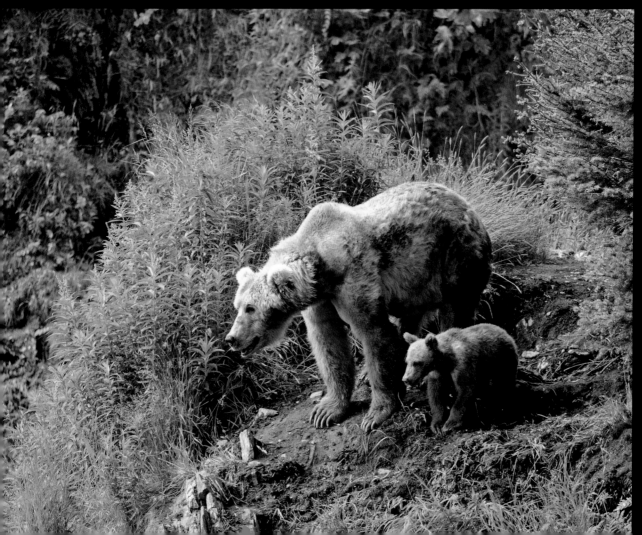

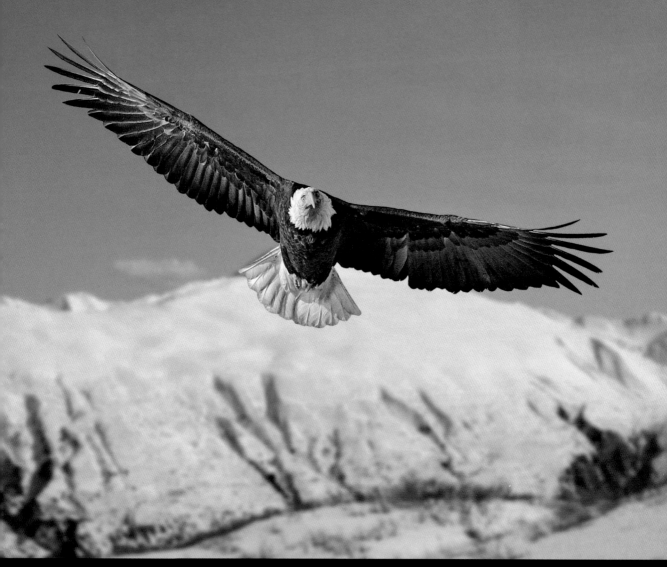

▲ It can take hundreds of shots and several all-day attempts to get the perfect angle on a subject, such as this majestic bald eagle in flight.

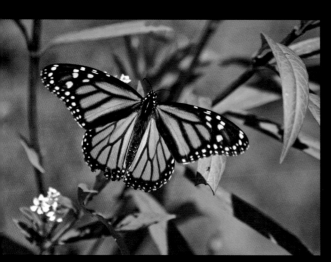

▲ Even getting great images of small subjects in nature can be hard work. I followed this monarch butterfly around all day until I got the one, perfect

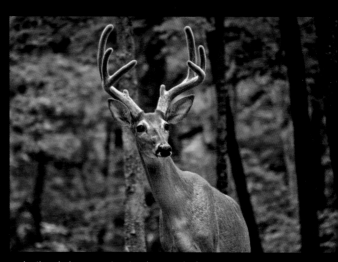

▲ Another elusive moment captured as a result of tremendous preparation before the actual photo shoot

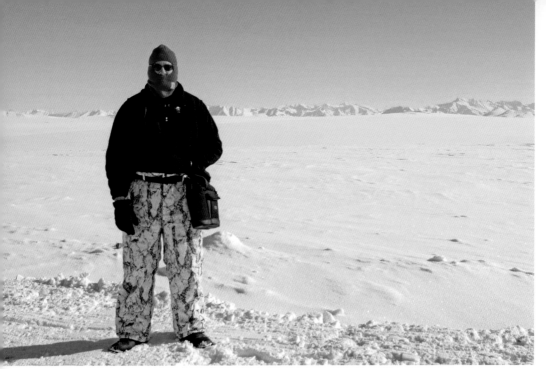

◄ Here I am bundled up while on a photo shoot in Alaska's North Slope. While it was very harsh spending time in an arctic environment, it was an unforgettable adventure, which is what nature photography is all about.

The Wildlife Photographer as Hunter

Make no mistake, to successfully photograph truly wild animals in their true, wild habitat, one must undergo many of the same preparations and have a skill set very similar to that of a hunter. The wildlife photographer who ventures far off the beaten path must be able to survive and thrive in rather unforgiving, extremely remote settings. To successfully capture images of one's targeted subject in the natural world, one must have a thorough knowledge of that subject, be able to scout out and locate areas where that subject dwells, have the skills necessary to get within camera range, and do so respectfully and safely. Like a well-seasoned hunter, the wildlife photographer must have a tremendous amount of patience, perseverance, and the ability to stay focused and comfortable in some very uncomfortable situations. Expecting the unexpected and being fully prepared for whatever Mother Nature dishes out from day to day is a must. Perhaps most important-

ly, the successful wildlife photographer must have an undying, childlike sense of adventure and wonder. After all, that's what it's all about. While it can get nasty and dangerous out there in the bush, and one often lives and feels like a wild animal while in pursuit of one, when it's all said and done, it's a joyous excitement that culminates not only in incredible photographs but also in unforgettable, priceless experiences that one can pass down to their tribe for generations to come.

Also, keep in mind that the fruit of one's effort as a wildlife photographer goes far beyond just great images and epic memories from quality time spent in the field. In adopting the mindset and disciplined skills of a hunter, one's sensory powers are greatly increased. Hunting sharpens one's senses to a razor edge! When I return from extended outings in the wild, I find that I'm hypersensitive to the subtlest of sounds, movements, colors, aromas, etc. All of my senses are on fire and operating on an extremely elevated level. It's an incredibly

rewarding feeling to be so tuned-in and connected to both one's external surrounds and also to one's interior physical capabilities.

Developing "The Eye"

This elevation of the powers of one's senses and overall awareness, and being consciously aware of it, in turn, plays an immensely important role in developing "the eye" that a photographer strives to possess. Developing a hypersensitivity to visual detail enables one to instinctively recognize potential photographic composition. One's time on a photo shoot is used much more efficiently when one can simply look at a scene, evaluate it in the blink of an eye, and instantly know if it will produce the kind of images one is after. The images below and on the next two pages are a few examples.

Keep in mind, there is an enormous difference between simply having the power of

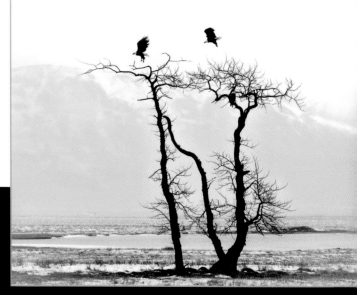

► A barren cottonwood tree in the midst of a harsh winter background was perfect for this bald eagle photograph.

▼ The light hitting the rippling water at just the right angle was a great compositional element for this swan photograph.

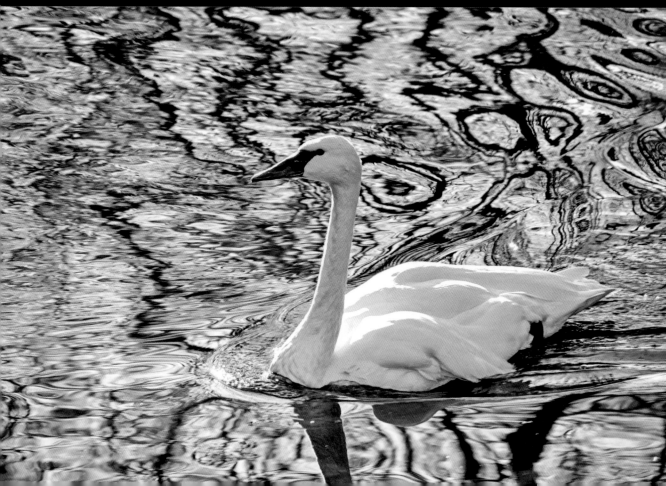

▼ **Top left:** Recognizing the potential of man-made compositional elements is important too, such as the "Keep Off" sign that this enormous bear completely ignored.

▼ **Top right:** Learning to instinctively predict the movement of one's subject, such as this fox hunting a bird, develops with quality time spent in nature.

▼ **Bottom:** Sizing up lighting conditions, proportionality, and visual flow in a matter of seconds, as I had to do with this bear river crossing image, are all a part of developing the photographer's "eye."

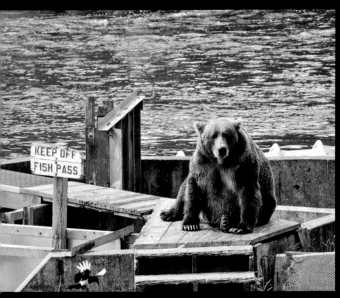
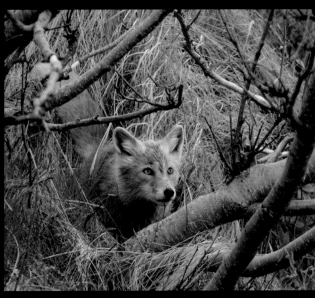
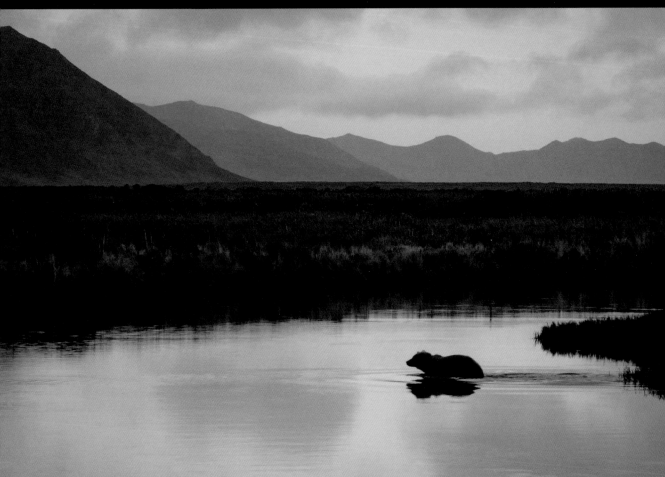

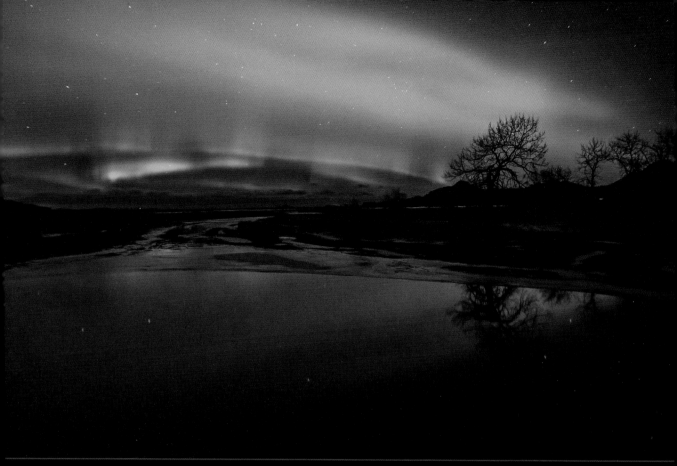

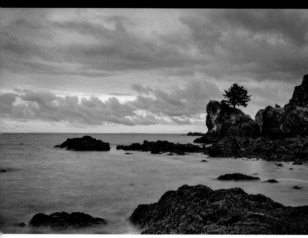

▲ Respectfully spending time in the natural world is rewarded with experiences such as this: a marvelous winter display of the aurora borealis on a deserted Alaskan river.

◀ While the powerful forces of nature can be dangerous, they can also produce great beauty, such as this long exposure shot of the otherwise raging sea.

vast amounts of information and data in a split second. Everything one sees tells a story and can lead to the discovery of great beauty, which of course is what a nature photographer hopes to capture and immortalize.

Appreciation of Nature

Finally, and most importantly, the more one becomes an active participant in the natural world by spending quality time in it, the more one gains an appreciation for the delicate

vision and truly seeing. The disciplined training of one's eyes promotes the harnessing of the power of vision to seek out minuscule details and gather information that would otherwise go unseen and unknown. The untrained eye takes many things for granted and glances over

balance of life on our planet. The wild world is both a beauty and a beast. Nature is not a Disney movie, and it must not be approached as such. While there is tremendous allure in the wilderness, there is also savagery in the struggle for survival. Both extremes are a reality that ultimately produces balance and life for the next generation. No matter what the inspiration or motives may be for entering the wild—be it hunter, photographer, etc.—those motives must be rooted in the deepest spirit of respect. In return, respect for nature is indeed rewarded, and this too is something that will shine though in a photographer's work.

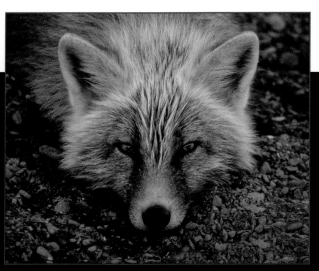

▲ As the wildlife photographer discovers, nature is both a beauty and a beast. Here we see the beauty of an adorable red fox.

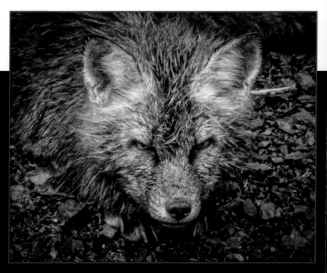

▲ And here we see the more vicious side of a fox.

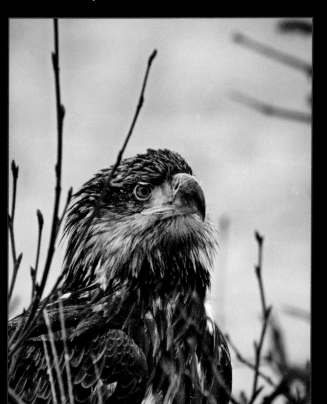

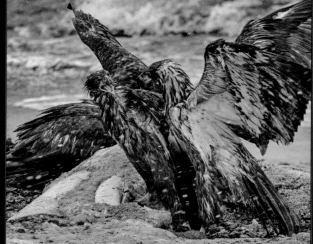

◄ Here we see what appears to be the innocence of a young bald eagle.

▲ And here we see that same immature bald eagle trying to kill a rival over a meal.

2. Preparing for the Field

When a wildlife photographer is in the process of seriously considering venturing out into nature in pursuit of a particular animal to photograph, the task can be a rather daunting one. There are many, many matters to consider and plan for—especially if the targeted subject lives in areas of wilderness that are extremely remote, dangerous, or a very long way from home. Even if a photographer wishes to capture remarkable images of local, native species, it can still be a difficult task to find and photograph those creatures with one's camera, as the more an animal is pressured, the more elusive it generally becomes. Keep in mind, there is a *huge* difference between photographing truly wild wildlife, in their true, wild environments, where the animals are not habituated to or tolerant of human beings, and that of photographing "wildlife" in places that are more like glorified zoos, such as certain national parks and areas that are visited by countless tourists each year. That being said, there is certainly nothing wrong with photographing wildlife in more tame, safe, easily accessible areas. In fact, that's exactly what I recommend for practice and training. More about that later.

Locations to Explore

For those interested in a more genuine, "wild" experience of photographing wildlife, where and how does one begin the journey? A fairly easy starting point is to seek out a reputable tour or guide service through some online investigation or through the travel bureau or chamber of commerce of an area of interest. Be aware, though, that many of these services cater to the general touring public, not necessarily those with a serious photography agenda. There are, however, more and more "photography guides" emerging these days who work specifically at helping clients get the kind of images they are after and who have a strong photography background themselves. I run such a service here on Kodiak Island, Alaska (www.wildrevelation.com).

66 Going the 'do it yourself' route is an extremely rewarding and educational path. 99

The more challenging option for seeking out potential hot-spots for wildlife photography is to do all the research and investigation on one's own, which can be a time-consuming and complicated task. However, going the "do it yourself" route is an extremely rewarding and educational path, which I personally enjoy very much, as that is a major element of a true hunting experience.

If one chooses to scout out prime locations for wildlife photography on one's own, there

▲ Visiting a Department of Fish and Game, Conservation Department, Wildlife Refuge, or the headquarters of other similar organizations will offer a wealth of information about the wildlife and habitat one is interested in photographing.

▲ A local Visitors Center or Chamber of Commerce is a great source to find out about businesses and services that may be of valuable assistance in planning a wildlife photography adventure.

are many easily accessible sources of information that are usually just the click of a mouse or a phone call away. For starters, websites run by Departments of Fish & Game, Conservation Departments, Departments of Natural Resources, State and National Parks Departments, etc., are all goldmines of information. Most of these organizations have tons of maps, detailed visitors guides, and bucket-loads of free materials about the natural resources, wildlife, and accessible lands in their particular geographical location. Along those same lines, talking with the biologists who work in those locations is another often overlooked source of extremely valuable information. Additionally, talk to park rangers, wildlife officers, conservation agents, hunting/fishing guides, farmers, and those who live and work in the areas you want to visit and photograph. Yet another way to locate areas that have high concentrations of targeted wildlife, or at least the best potential for holding magnificent game animal species (if you wish to photograph game animals, that is) is by checking the databases of hunting organizations such as the Boone and Crock-

66 Talk to park rangers, wildlife officers, conservation agents, hunting/fishing guides, farmers, and those who live and work in the areas you want to visit and photograph. 99

▲ Taking a class at a community college, talking to biologists and professors, and spending quality time at the library are all highly productive ways to gain essential information about the animals one seeks to photograph.

ett Club, Pope and Young Club, Safari International, etc. These organizations keep detailed records of what states, counties, and countries "record book" animals were harvested in.

Again, doing all the homework, research, and investigation of such matters on one's own can be a lot of work. But, it's great fun, and the knowledge gained will only serve to make one a better, more educated photographer for the future, and in the end will result in new friendships, professional networking contacts, fantastic adventures, and most importantly, great photographs.

Armchair Photo-Hunting

Most wildlife photographers consciously choose a particular animal to seek out and photograph for the simple reason that they are fascinated by the qualities and characteristics of that subject. Whether it's the animal's beauty, grace, elusiveness, social behaviors, predatory capabilities, etc., there is something that attracts one on a deep level. Many develop a spirit of kinship and feel an almost personal connection to a particular species. That initial

inspiration and photographic interest starts a long relationship with an animal and the land in which it dwells.

When a hunter is preparing to pursue a certain animal, he must learn all he can about that species and its habitat. He must study the animal's every behavior, spend quality time living where the animal lives, and become intimately familiar with virtually every aspect of the animal's existence. He must get inside the animal's head, know the animal's land, and understand its instincts. A successful hunter must, in essence, become the animal he pursues. The same holds true for the serious, dedicated wildlife photographer.

Before a photographer packs his or her bags and heads off to the wild for an adventurous photo shoot, it is necessary to learn all one can about the targeted subject and its habitat. One must become an "armchair hunter" before doing the actual photo-hunting in the field. Of course, the level of education and study that one may need to acquire for a successful time in the field also depends on whether the photographer is going with a guide or not.

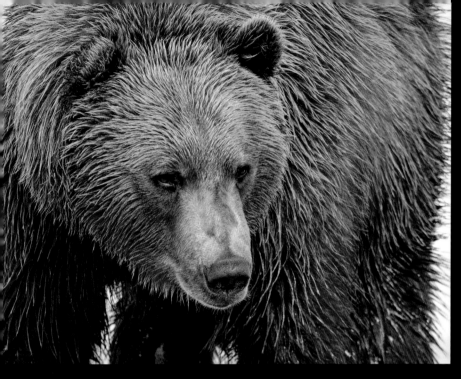

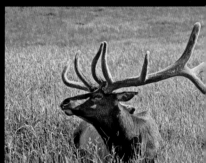

◀ ▶ **This page and facing page:** Every wildlife photographer naturally develops an interest and specialty for photographing certain animals. Bears, elk, and eagles have been a life-long interest on which I have focused much of my time and energy.

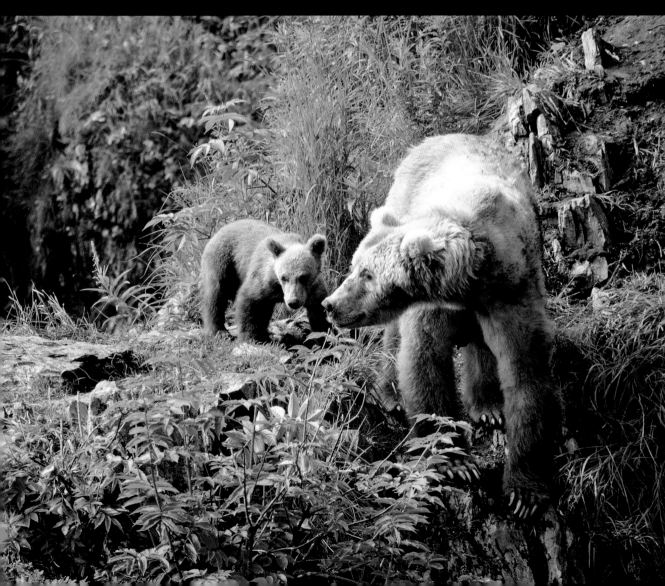

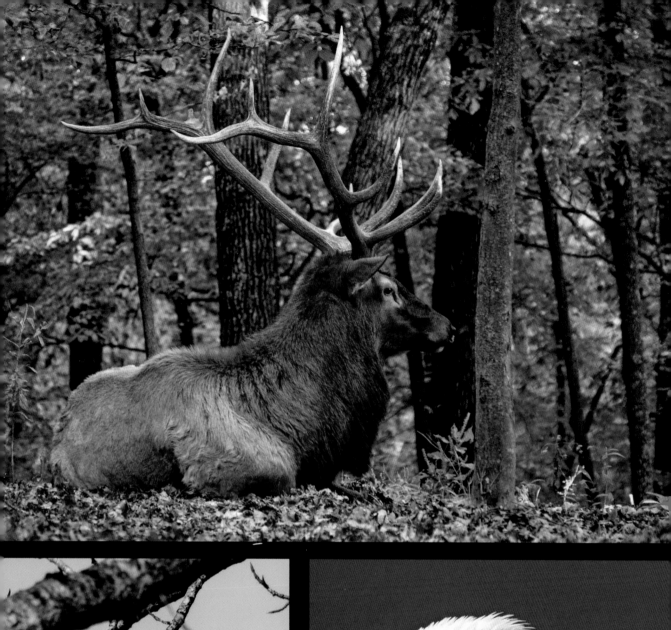

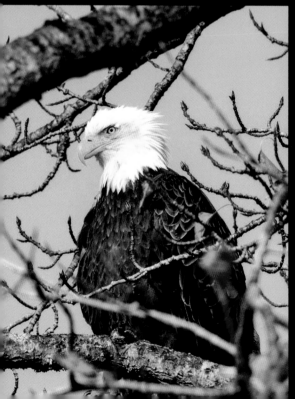

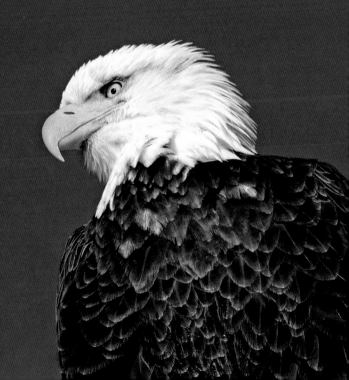

▲ Learning all one can about one's target subject for a wildlife photo shoot is not only a prerequisite for success, but it's also an enjoyable pastime.

Either way, knowing all there is to know about one's subject and its environment enriches the photographic experience all the more. Not to mention, again, it's just plain fun to learn more about wildlife and the places they call home. Education is always rewarding in and of itself. I'll discuss more of what to specifically study and know about your targeted photography subject in a later chapter about scouting, so stay tuned.

Thankfully, in the information- and media-saturated world that we live in these days, there are countless sources of readily available information to acquire an astounding amount of knowledge about most any particular animal. There is enough online reading material out there to keep one as immersed in study as one wishes to be. Along with that, one can find many online videos about a particular species of wildlife. Naturally, there are the more traditional means of study as well: a trip to the local library, visiting a nearby university, taking a class at a community college, bookstores, magazines, DVDs, etc. Spending time in a comfortable chair and loading up on all the intellectual fuel one can will pay off tremendously when in the field.

One important word of caution, though: be sure the materials you are reading and consuming are from good sources. Keep it as objective as possible. Try to stick to materials written and published by reputable scientific sources, not those with overblown, emotional, or subjective agendas. In regard to the subjects of wildlife and the environment, there is a lot of misleading nonsense on both ends of the spectrum. There are some animal-rights and environmental organizations out there who simply don't have a clue, who have never stepped foot in a truly wild environment, and who base their philosophy on a Disney-like understanding of nature. On the other hand, there are some hunting and outdoor organizations that also dish out false propaganda rooted in self-serving agendas. So, again, I highly recommend keeping one's sources of study focused on materials written by those whose work flows from experienced, objective, scientific/biological fact. And as a final bit of advice, take plenty of notes as you study, especially in regard to what to look for and pay attention to out in the field—and, of course, don't forget to take your notebook with you when you head out. More about this to come, as well.

Physical Training

Along with training one's self intellectually for a wildlife photography adventure, it is also very important to be physically ready. Again, the level of preparation and conditioning that one may need will depend on one's objectives and goals for the trip. If you are going with a guide or tour service and will be taken directly to photographic locations in a vehicle of one kind

or another, staying in a camp or lodge with modern comforts, etc., you may not necessarily need to be in tip-top shape. On the other hand, if you are going to be exploring vast areas of wilderness on foot, camping primitively, enduring weather extremes, etc., you will need to be physically (and mentally) prepared to be pushed hard and take some serious beatings from Mother Nature.

There are many options for getting in shape and many forms of exercise that are great for wilderness exploration, but the best exercise and training is simply to imitate what you will be doing in the field. Exercising and training in natural environments is naturally a better choice than going to a gym. The more time one spends in nature, the more one learns her ways, gets acclimated to her temperaments, and

▼ The best training for spending time in the outdoors is simply spending time in the outdoors.

begins to get more in tune with her rhythms, which are all immensely beneficial for a wildlife photographer. Mimic what you will be doing on location. If you are going to be taking long hikes with a heavy pack of gear on your back, then load up your backpack and hit a nearby hiking trail, or simply walk a few miles around a hilly neighborhood somewhere in the same footwear you intend to use on your trip. If you do not live in an area that has at least some similarities to the terrain you will be encountering, then walking on a treadmill with elevation adjustments is a good alternative. No matter what you end up doing for your training, though, don't forget to consult with your doctor before beginning a more intense exercise regimen.

Safety First

There are many best-selling books and popular films that chronicle the experiences of those

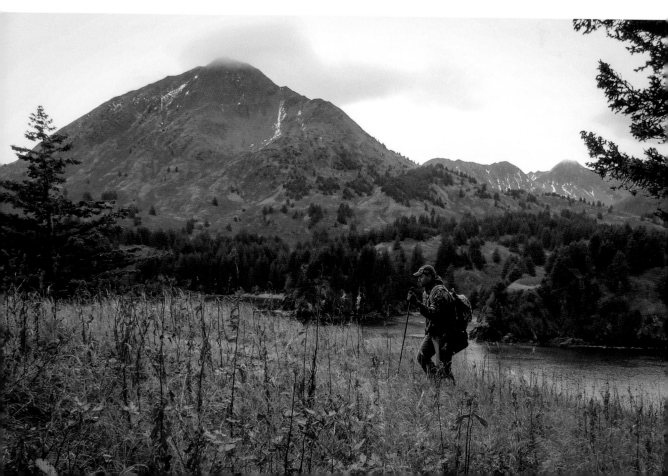

who have ventured into the wilderness for one reason or another, only to have their outing turn into a harrowing struggle for survival in the face of catastrophe. In many of those stories, the main characters make it out alive, claiming victory over the temperamental ways of Mother Nature; in others, they are not so lucky. While such stories might make great fodder for compelling reading—and movies of outdoor demise can be a rollercoaster thrill ride, to say the least—it is not so compelling or thrilling when it is you or your loved ones facing a true, life-threatening emergency while in remote areas of wilderness. Safety and diligent preparation for one's time in the field are of the utmost importance when planning to spend time in remote areas. And, of course, the more remote one gets, the more carefully and thoroughly one must be prepared for emergency situations.

Naturally, getting ready for a wildlife photo-safari is very exciting! Traveling to new places, exploring new lands, spending quality time immersed in the beauty of creation, and capturing those experiences with one's camera is what serious nature photographers live for. But no matter how exciting or rare a particular photographic opportunity/experience may be, it's never worth dying for or worth putting

> 66 Whether you are planning a tame, local daytrip or being dropped off in the extreme Alaskan wilderness for two weeks, covering all the bases of pre-field preparation is a must. 99

others in serious risk. It's very important not to let all the excitement and giddy anticipation cloud one's thinking while in the preparation stage. Those preparations must be made with extreme care and hypersensitive attention to detail.

Whether you are planning a tame, local daytrip or being dropped off in the extreme Alaskan wilderness for two weeks, covering all the bases of pre-field preparation is a must. It will ensure a fun, safe, and fruitful time. While much of what I'll be covering throughout this chapter applies to more advanced, serious wildlife photography outings, many of the same principles apply to those simple daytrips as well. And if you are planning a photo-adventure with a group, it is imperative that there is constant, thorough communication with the other members while making field preparations. Planning and going over every tiny detail together is a must. On the other hand, if one is going alone on a remote, advanced photography trip, first be aware that doing so can be a high-risk activity, and it is certainly not something for beginners.

Do a Reality Check

In my opinion, the first step in the way of preparation for time in the field, especially for those more advanced adventures, is to do a brutally honest reality check. Ask yourself, "Am I really ready for this? Am I in good mental and physical shape? Do I have the necessary tested skills? Have I done my homework in regard to the area I'll be in? Have I carefully planned for every conceivable scenario of this adventure? Etc., etc.?" One has to approach the wild with ultimate respect! The wilderness is no place to fool around or do things half-heartedly. Hospitals, medical assistance, and help of any

kind are often miles and even days away. Even with emergency devices such as an EPIRB (emergency position indicating radio beacon) or a satellite phone, getting help can still be next to impossible. If the weather turns south while out in remote areas of wilderness, which you can expect, forget about anyone flying in to rescue you. Even the elite emergency and rescue services of organizations such as the US Coast Guard are severely limited when the weather gets extreme. In most cases, the only helping hands out in areas of remote wilderness, especially if one is going "unguided," are at the end of one's arms.

Do Your Homework

In gearing up for a serious wilderness photography adventure, it is imperative to do your homework well in advance in regard to the actual location you will be spending time in. This is where that "armchair hunting" comes into play. Get quality, up-to-date maps, find a quality compass, study the topography, and review the available natural resources that are in the area for shelter, water, fire, and food. If there are discernible, useable trails in the area, become familiar with them on your map. While high-tech gadgetry like GPS units and smartphones can come in handy, never trust your safety and overall well-being to things that run on batteries. The skill-sets that one relies on in the wilderness must be embedded in one's brain and accessible through one's hands, not in an electronic box. Be well aware of the weather extremes that you might encounter because you will probably experience all of them. Be well prepared to deal with pests, both big and small—from hungry, camp-raiding bears to hordes of pesky insects that materialize when least expected.

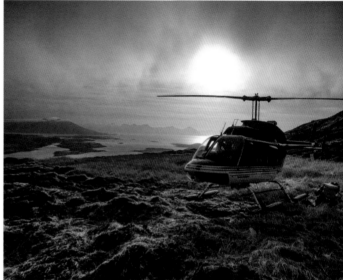

▲ Be aware that even the best of rescue efforts will prove limited or impossible in extreme weather. The remote wilderness is no place to fool around. Safety first, in all matters!

Check and Re-Check

Make a gear list well in advance based on your research of the area you are going into, then check, re-check, and quadruple-check your preparations before heading out (more on this in the next chapter). Also, keep in mind that if you are being flown into the wilderness, you are usually limited to around 100 to 150

◄ Gear must be kept to a functional minimum, especially when entering the wilderness by small boat or plane.

pounds of gear per person for most flights on a bush plane. What you pack has to be light, absolutely essential, simple, dependable, and as multi-purpose as possible. This is no time to forget anything!

Lapses of memory or blundering oversights simply cannot be a part of preparing for remote adventures. Your life may depend on what you happened to forget. While knowing how to improvise, adapt, and overcome is of the greatest importance (and it certainly comes into play at times), there is just no way out of certain situations without the proper gear—period. For example, if you wear contacts and/or glasses and absolutely depend on them, you had better bring an extra set or two with you. I've seen some incredible bush craft over the years, but I have yet to see someone make wearable prescription lenses from a chunk of ice. And if you rely on medications of one kind or another, take plenty of extras and keep them in separate places so you have a backup. Don't keep all your eggs in one basket, as they say. Lecturing like a worrisome parent, I could go on and on with more, but the bottom line here is that one must be extremely prepared for the rather extreme adventures that are a part of wildlife photography. There are lots of resources out there to learn more, but the important thing is to practice what you learn. Make it a point to field-test your knowledge and skills in areas that will not kill you if you make a mistake.

File a Safety Plan

A final and *extremely important* preparation to make before heading out to the wild is to have a written safety plan and to make sure several trusted, dependable people have copies of it. Your plan should cover where you will be photographing, where your camp location is, who is in your group, contact information for those people as well as their families, when you are leaving and returning, how you are getting to your location, contact information for guides, pilots, or transporting services you may be using, etc. All that being said, sometimes things change out in the field and there can be unexpected modifications to one's plans that occur. But still, try to give folks back home the most specific data that you can. A little bit of general information goes much farther for search and rescue personnel than no information at all.

3. Gearing Up

A major issue that comes to mind while preparing for a wildlife photography outing is what to pack. Preparing the right gear for a serious outdoor adventure, and getting it all organized and packed, can be just as daunting a task as all the pre-field research—but it can also be just as fun. With every piece of gear that is readied, the mind races with excitement of what it will be like to use it when the time comes. The pre-adventure planning and packing is a task filled with exhilaration and joyful imagination! Speaking personally, as I prepare for time in nature, whether it's a simple day trip or a hardcore, super-remote solo excursion, I often feel like a little kid preparing for Christmas. With each passing day leading up to the big shove-off date, I'm literally exploding with childlike glee and frenzied anticipation! I just can't wait to get out there and go!

My Packing List

To help you along with this phase of your photo-adventure planning, I'll share with you my personal packing list and offer some added tips and comments on each category. This particular list is one that will vary a little depending on the pursuit, but it covers all the major areas. It is a list that I have used for well over a decade and is based on countless hours of research, as well as in-the-field experience.

Hopefully, it will serve you as a good example and outline for your own packing efforts. And while it may seem like a lot of stuff, it can all fit in a couple of large-capacity duffel bags or other wilderness-proof luggage.

Bags, Storage, and Ties

Large frame backpack • Duffel or dry bags • Hard-shell case/totes Knee braces/back brace • 150 feet of 550 parachute cord • 100 feet of nylon rope • Zip ties/clipper • Heavy-duty garbage bags (large and small) • Ziploc freezer bags (large and small)

Notes: Before you start getting packed up, it's very important to have the highest quality packs you can afford. An external or internal frame backpack will provide plenty of room and rugged protection for the gear you will be carrying while in the field. Before purchasing a new backpack, though, I highly recommend trying it on at the store. Make sure the shoulder, chest, and lumbar straps are comfortable and fit properly. Along with a large-capacity backpack, a large duffel bag/dry bag or two will most likely also be necessary to transport all your gear to the field. Another option here is a large, hard-shell case, tote, or footlocker, which not only provides superior protection for more fragile gear but also makes great camp furniture. I also like to have handy a bunch of smaller dry bags or Ziploc bags for extra

weather protection—and as a way to organize gear that goes in the larger bags.

Lugging around a bunch of heavy packs can certainly take a toll on one's body, especially if there is a lot of hiking to do through challenging country. Having a set of knee braces and a back support can be a real life-saver, especially if one is prone to injury in those areas.

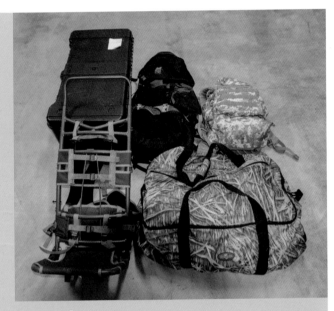

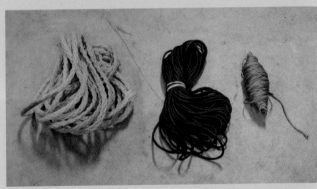

A good supply of parachute cord or nylon rope will serve many functions, but it is especially useful for camping chores. Also, large and small plastic zip ties work wonders for fixing and securing many of your items while out in the field. Along with that, a simple finger or toenail clipper works great for quickly cutting them loose instead of fumbling around with a large knife blade and potentially damaging your packs or gear.

Finally, one of the most important things you can have with you are a few heavy-duty garbage bags of varying sizes. I prefer the 50-gallon, commercial-grade bags for big chores and the kitchen-size bags for smaller ones. I could write an entire book for ways to use garbage bags out in the field, but most commonly they are used for extra weather-proofing for your packs, bags, and cameras, emergency rain gear, shelter and insulation material, a dry place to sit in cold, wet environments—and, last but not least, they are great for collecting trash!

Camera Gear

DSLR camera • Lenses • Lens filters • Extra memory cards
Point and shoot camera • Tripod/monopod • Batteries and chargers
• Solar charger • External shutter release • Lens and sensor cleaning
supplies • Anti-fog wipes • Laptop computer

Notes: The camera gear you bring will depend on what you intend to shoot and if you need to do any photo viewing/editing in the field. The above list covers the basics; you should add to or subtract from it depending on the demands

◄ **Top:** Do a test run with your luggage and packs to make sure they will accommodate your needs in the field.

◄ **Center:** A supply of nylon rope, twine, and parachute cord will serve countless purposes in the wilderness.

◄ **Bottom:** Large, heavy-duty garbage bags serve a variety of needs – most especially waterproofing items such as sleeping bags.

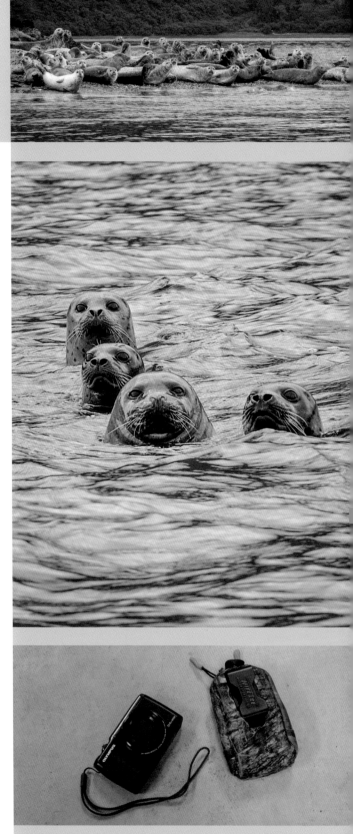

▶ **Top and center:** Great photos can be produced from high-quality point-and-shoot cameras, which generally capture images in JPEG format.

▶ **Bottom:** Keep a high-quality point-and-shoot camera readily accessible at all times! Consider it your "side-arm" as a wildlife photographer. Also, make sure you have a durable, weatherproof case to go with it.

of your particular outing. One thing I would recommend is having a high-quality point-and-shoot camera easily accessible at all times. Things can happen fast and unexpectedly out in the field. Awesome photo opportunities can occur when your main camera is not handy. Thus, being able to at least shoot high-resolution JPEGs from a smaller point-and-shoot camera can be the difference between getting the shot of a lifetime or totally missing out. There are some great little cameras out there these days—some that can even shoot in RAW formats. So, get the best one you can afford and keep it ready for action at all times!

Self-Defense and Deterrents

Firearm • Pepper spray • Noisemaking devices • Packable electric fence • Proximity alarm

Notes: The items in this category will greatly depend on whether you are in an area of wilderness where humans are not at the top of the food chain. If you are photographing potentially dangerous animals, or simply camping and exploring in an area where dangerous predatory animals live, it is a very good idea to have something for personal protection. There are both lethal and non-lethal means of self-defense and animal deterrent devices available. Firearms can be used as both. In many cases, having a gun out in the field (where legal, and if one is properly trained to use it) acts mostly as an intimidating noisemaker.

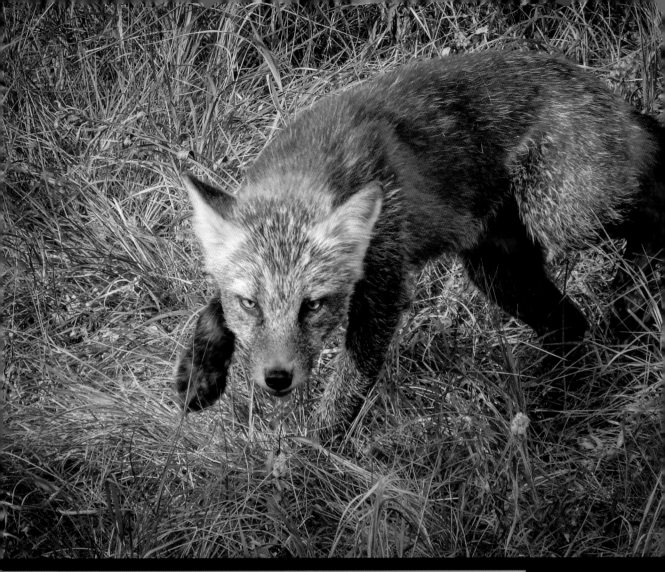

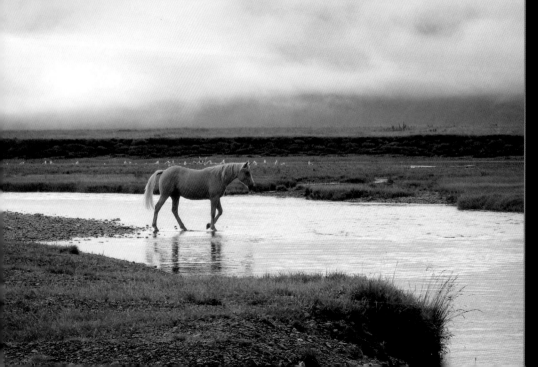

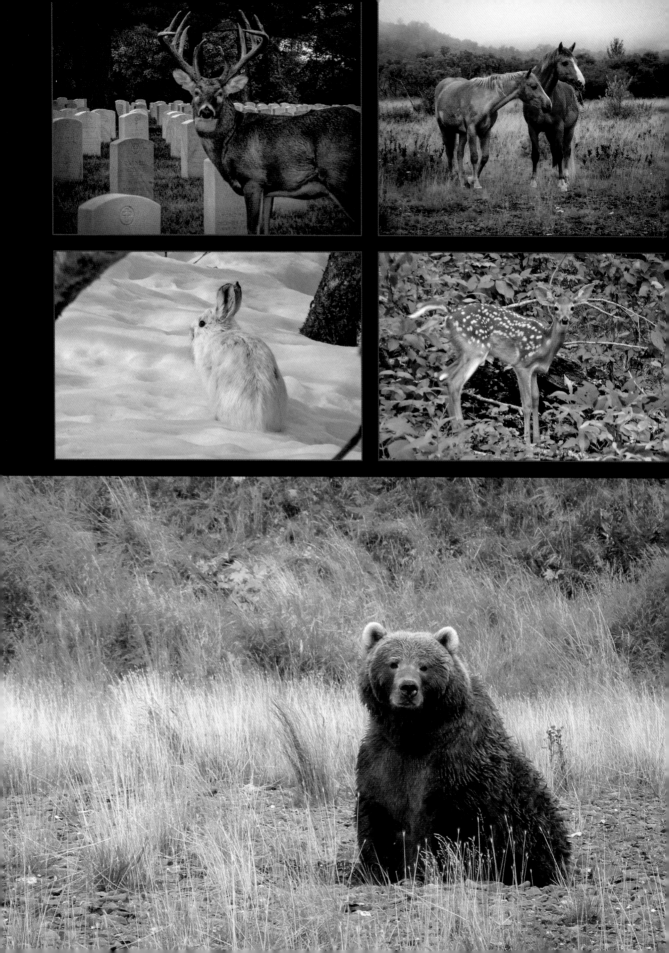

Most critters will run for their lives at a close-range deafening blast; if not, a properly used firearm can mean the difference between life and death in the extreme, rare occasion of an attack. A firearm also works well as an emergency signaling device when fired in repetitions of three, which is a universal distress signal.

In regard to firearms, there are many options as far as makes, models, calibers, ammunition, etc. While many pack large-caliber handguns into dangerous wilderness areas, perhaps a better option is a short-barreled, pump-action, large-capacity shotgun, which can be loaded with both lethal and nonlethal ammunition. This is a popular choice for professionals who spend a great deal of time around dangerous animals. One can first fire a few rounds of nonlethal ammunition to hopefully ward off an aggressive encounter—and, if necessary, reserve the last few rounds in the magazine for lethal ammunition in a worst-case scenario. No matter what you choose as far as a specific weapon, though, the most important points are to first make sure it is legal where you are going, that you are properly trained and confident in using it, and that you practice gun safety at all times for the well-being of yourself and others.

Other nonlethal forms of self-defense and deterrents include animal-grade pepper spray (not the stuff used on people) as well as fireworks, flare guns, etc. Basically, anything that makes a loud, scary noise or causes a temporary, painful sensation for the animal can be effective. A word of caution about pepper spray: in windy situations, it can come back and incapacitate or permanently injure the user. Also, if pepper spray goes off inside a vehicle/plane, it can have fatal consequences for the entire party. Make sure you tell your pilot, boat captain, or driver if you have any in your pack so it can be properly secured for travel.

Another effective option for keeping animals out of one's camp is a portable electric fence. These have truly revolutionized the way people live and work in places like Alaska, and they can certainly be used anywhere in the world. Believe it or not, a small, packable fence setup that operates on a few simple flashlight batteries can generate enough shock to send a thousand-pound bear running for the hills!

A proximity alarm works nicely in conjunction with an electric fence or by itself. This is a small motion-detecting device that emits ear-splitting shrieks when triggered. Set up one or two of these in strategic locations around your camp and you are good to go. They can also be used during photo-shoots to signal something dangerous coming up behind you on the trail or through the brush.

Camping

Tent • Ground tarps • Sleeping bag • Sleeping clothes and hat Pillow • Insulated sleeping mat • Flashlights/headlamp, batteries/bulbs • Duct tape • Five-minute epoxy, superglue • Portable bow saw, extra blades • Camp shovel • Bug repellent and head net • Cooler Bungee cords • Camp chair • Pruning shears, machete • High-quality fixed blade and folding knives

Notes: Most of the items in this category are fairly self-explanatory, but I will offer a few additional comments about some of them.

▼ Whatever weapon or deterrent you choose, it must be legal in the area where you will be photographing and you must be trained in its use.

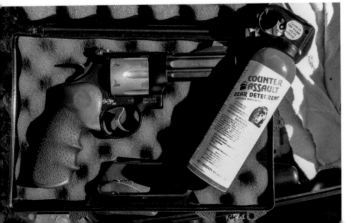

Needless to say, there are lots and lots of options out there these days for camping gear. Take a look through a Cabela's catalog or visit a major sporting goods store and you will be dumbfounded at all the gadgets and gear available. So, I'll preface my notes here by recommending quality products that one has confidence in. If you do not have much experience in the ways of more advanced camping, then I'd recommend you talk to those who do, or simply check out some online reviews of products you are considering for purchase. The gear you choose can make or break a wilderness adventure. It can even be the difference between life and death.

A tent that is rated as a "four season" model will be able to handle most any situation when set up on top of a good ground tarp for added insulation and protection. It's also ideal to have an extra tarp or two handy for additional shelter and insulation/protection purposes.

In regard to a sleeping bag, make sure it is rated for the weather conditions you will be encountering. It's also very important to keep it dry at all times—no matter what! A warm, dry sleeping bag can be a genuine lifesaver if one finds him or herself in a hypothermic condition. Whatever you do, *do not* sleep on top of one of those big, cheap air mattresses! As the air inside of them cools down at night, they become a source of major conductive bodily heat loss, even in warm or hot climates. A foam sleeping pad, or a small, heavily insulated inflatable pad are the best options.

Duct tape, five-minute epoxy, and superglue can fix almost anything in the field, with a little ingenuity, so it's good to always have some along. Also, superglue can be used as a "liquid bandage" to mend cuts if more traditional bandages are not available.

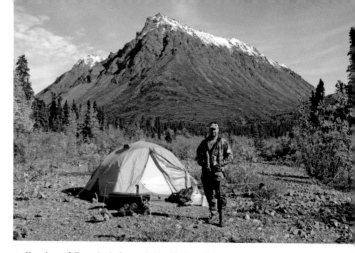

▲ Here is my fully protected camp in the Alaskan wilderness. I had bears, moose, and other large critters all around me, but a portable electric fence and proximity alarm kept me and my belongings safe.

A high-quality fixed blade and folding knife, bow saw, set of pruning shears, machete, and camp shovel can be used for all sorts of chores, from cutting firewood to digging a latrine. Also, a small set of pruning shears is handy for strategically cutting out limbs, brush, or other obstacles that may be obstructing one's camera shot while photographing from behind blinds or natural cover. More about that later.

A quick word about pest control. While insect repellents that contain DEET work well at keeping the bugs away, it is important to keep in mind that DEET is a heavy solvent that will literally melt plastic and other materials, which (by the way) a lot of camera gear is made of. If you use a DEET-based repellant, use it sparingly, never get it on your terminal gear, and wash it off your hands immediately. There are some non-DEET products out there these days, but few that can rival its repelling power. One product that comes close, however, is an herbal-based product called Herbal Armor. I've used it in some of the most horrible infestations of biting bugs imaginable, and it worked great! While the bugs may still buzz around and drive you crazy, at least they won't bite.

▲ A roll-up, inflatable, insulated sleeping pad is a great choice for sleeping comfortably.

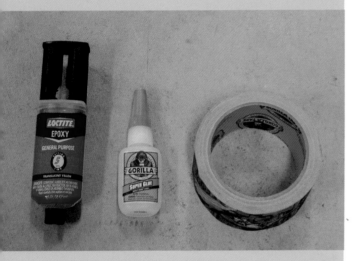

▲ Five-minute epoxy, superglue, and duct tape can fix just about anything on earth. Never leave home without them!

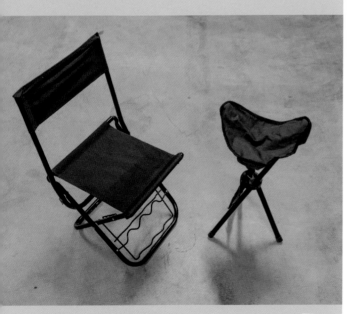

▲ Small, collapsible camp chairs come in many styles. Find one that is comfortable, useful in various types of terrain, and easily packed.

In my experience, the first and best line of defense for bug protection is simply wearing durable clothes that cover the body completely and using a fine-mesh bug head net. When photographing animals in buggy places for long periods of time, there is nothing that works as well and is more relieving than a good ol' head net. I keep one handy at all times. Remember, too, that there is a difference between biting and burrowing bugs. While total-coverage clothing and a head net will keep away flying pests, insects like chiggers and ticks will burrow right into areas around one's ankles, waist, collar, etc. Spraying a DEET-based repellent around these areas on one's clothing (while keeping it off one's hands and gear) is highly effective in areas with these nasty and often disease-carrying pests.

Finally, having a small collapsible or portable chair of some kind is great for around camp and essential when photographing in certain situations—like from behind a blind for hours on end. Another option is a 5-gallon bucket; this can be used for carrying water or supplies, but it also makes a great stool. In fact, they make padded seat cushions that go right on top of a bucket for added comfort.

Clothing

Traveling and camp clothes • Layer system of field clothing (camouflage or natural colors) • Belt • Boots • Camp shoes • Packable hip waders • Gloves (light and heavy) • Hats (brimmed and stocking) Camouflage face mask • Chemical hand/toe warmers

Notes: Wearing the proper clothes in the field is another matter that can become one of life and death. A common saying in Alaska where I live is, "Cotton kills!" Cotton clothing is comfortable and fine for traveling or lounging around camp on a nice day, but it is not suitable for

serious use in the wilderness. Cotton is very absorbent, and when one works up a sweat or gets wet from rain, cotton clothing holds the moisture in, close to the body. When combined with a drop in temperature or high winds, this greatly accelerates a major drop in one's core body temperature, resulting in hypothermia and possibly death. Hypothermia is the biggest killer in the outdoors, and it can set in even when it's as warm as 60 degrees (F).

When planning what to pack for clothing, use a layering system. First on the list is a base layer of clothing, which is essentially socks and underwear ("short" and/or "long" underwear). Your undergarments should be made of a moisture-wicking material that helps in regulating body temperature. There are many options these days as far as actual fabrics, so I'd suggest doing some further study and experimenting with one you find to be comfortable and effective at wicking away sweat and moisture from your skin.

The middle layer is clothing that acts as insulation by trapping and warming body heat. Wool is a popular choice, as it insulates in both wet and dry conditions—but, again, there are many options these days, so I recommend doing some research. Another important point to keep in mind is the "noise factor" of fabrics. If you are trying to stay quiet while in earshot of a wild animal, wearing clothing that makes a lot of noise when you move will not do. Many animals will be long gone before you even know they are there. I'll discuss more about the topic of "invisible clothing" later.

A very important consideration is the quality of the shell layer. You can purchase generic or off-brands of base and middle layers to save a few bucks, but do not skimp on the shell layer! I've seen low- and even middle-quality wind

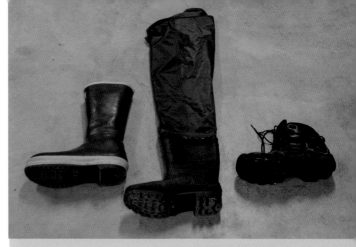

▲ The footwear you choose will greatly depend on the habitat where you will be photographing. Just make sure your boots or shoes are well broken in before your trip!

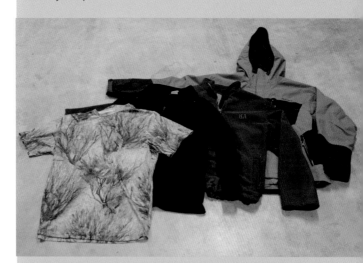

▲ Using a layering system of clothing will keep you comfortable in any weather condition, as well as promote proper bodily thermoregulation.

and rain jackets literally rip right off of people in severe weather or while walking through heavy brush. While lightweight, "breathable" fabrics may be fine in moderate wind and rain, they are worthless in heavy-duty, multiple-day downpours. If you are going to be in extremely rainy and windy climates, I'd suggest investing in a set of raingear like that worn by commercial fisherman (brands such as Helly Hansen or Grundens). While industrial-strength, professional-grade raingear is certainly not all

that quiet, it really doesn't matter in a noisy, torrential downpour.

Along with a well-planned, quality layer system of clothing, you will also need gloves, a hat (for both warmth and to keep the sun out of your eyes), and high-quality footwear. A good set of boots is another area to not skimp on. Get the best you can afford—and be sure to break them in long before your trip! Also, if you are going to be in an area where there will be deep water, creeks, or swamps to wade through, a set of packable hip waders will go a long way. And finally, have a comfortable pair of shoes and a separate set of clothing strictly for use in camp. Try to keep your "hunting/photographing" field clothing separate and away from anything that will contaminate it with human scent. More about that in the next chapter, as well.

Food

Instant oatmeal (daily pre-portioned) • Honey • Raisins • Dried fruit Dried fish or meat (jerky) • Bread • Peanut butter • Freeze-dried meals • Nutrition/granola/power bars, etc. • Nuts • Cheese

Notes: The food you take will be a personal choice, of course. It is important to have food that is nutrient-dense, plus easy to pack, cook, and clean up afterward. The wilderness is not necessarily a place to be on a diet. Foods that

are high in fat and carbohydrates are necessary to fuel the body for the rigors of the outdoors and to keep the body generating heat. While protein-rich food items are also important, don't forget that the more protein one consumes, the more water it will take to digest and metabolize it—and water may not be all that easy to find or purify, depending on the location. Freeze-dried meals are a popular choice for field use as they are fairly tasty, nutritious, easy to pack, and quick to clean up. However, they must be prepared with the proper amount of water (or even a little more) to fully hydrate them. Consuming an under-hydrated freeze-dried meal can cause serious digestion problems and can ruin a trip in a hurry!

Cooking

Camp stove and fuel • Utensils • Lighter/matches • Cooking vessels Plate, bowl, cup • Paper towels • Small grill • Dish soap • Scouring pad • Can opener, multi-tool • Aluminum foil

Notes: Your cooking items will depend on what it is you plan to cook, but the above list will hopefully give you an idea of some basics to pack. Again, there are lots of options out there for camp cookware, so do some further research and experimenting to find what will work best for your trip.

◄ Freeze-dried meals are fairly tasty, nutrient dense, very lightweight, and easy to clean up. However, if not thoroughly re-hydrated, they can cause digestion problems.

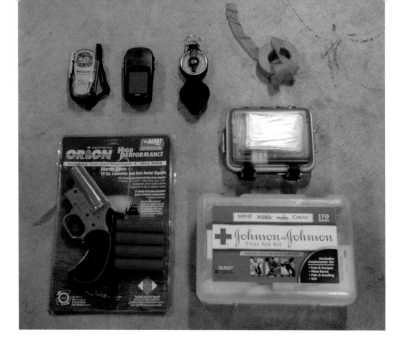

▶ Safety first! Be intimately familiar with your safety and survival gear.

Drinking

Water purification • Water bottle • Powdered Gatorade/Tang, etc.
Powdered milk • Instant coffee, creamer • Collapsible water jug or two

Notes: What you take along on your adventure to drink is another matter of personal choice, but the most important thing is water—and lots of it! It's vitally important to stay properly hydrated at all times. Be sure to pack water purification gear, whether it is a mechanical filter, a chemical system, or a large container and enough fuel to boil water. Taking along a big supply of your favorite canned or bottled beverages is simply not practical in most situations, so even though it may not taste as good, powdered, or "instant" versions of things like milk, coffee, etc., are a much better choice for extended stays in the wild.

Photo-Hunting

Field notebook • Wildlife calls • Attractor/cover scents • Wind checker
Binoculars • Blind material

Notes: These are items I'll be covering in the next chapters—so, again, stay tuned.

Safety

First aid/survival kit • Maps • Compass • Satellite phone
EPIRB (Emergency positioning indicating radio beacon) • GPS, batteries
Flagging tape

Notes: Survival, first aid, and safety are all areas that you should be well versed in before heading out into the wild. You do not necessarily need to be an expert, but having a working knowledge in these areas is essential. There are tons of books, videos, and workshops available to learn survival and emergency skills, so I certainly recommend doing further investigation and becoming educated in these matters. The survival skills you learn and practice, as well as your emergency gear, should be compatible with the geographical location you intend to be in. Being prepared and outfitted for a survival situation in a sandy desert won't be of much use in a rainforest. Finally, take the time to learn manual skills in the way of navigation and signaling for help instead of solely relying on fancy, high-tech devices. Don't trust your life to things that run on batteries.

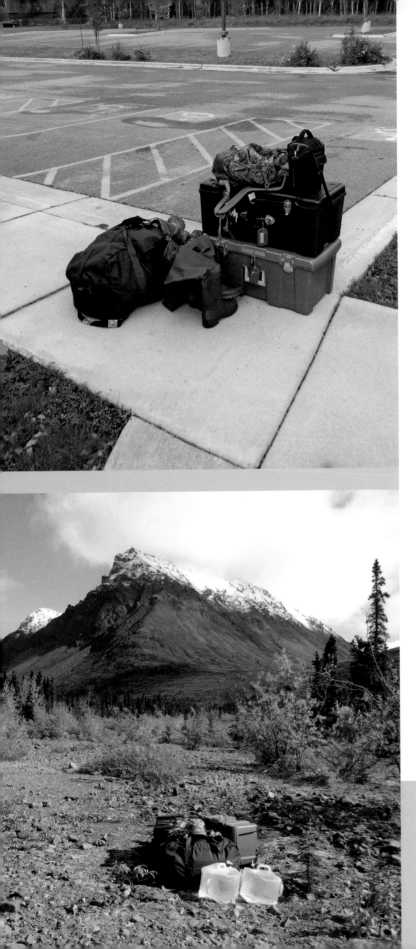

Personal Items

Cell phone • Sunglasses • Deodorant • Contacts/glasses • Toothbrush/paste • Vitamins • Soap, shampoo • Ibuprofen, aspirin • Journal, pens Chapstick • Washcloth, towel • Biodegradable toilet paper • Ear plugs • Antibiotic ointment • Mole skin/blister treatment • Thank-you cards and cash for tips

Notes: Your personal items are just that: personal. You know what you need much better than I. The above list outlines the basics to get you thinking. As I mentioned earlier, if you absolutely depend on contacts, glasses, medication, or other critical health aids, make sure you bring a backup supply. Also, a little token of gratitude can go a long, long way. I always like to have an extra supply of cash on-hand to tip drivers, pilots, guides, hosts, etc., as well as thank-you cards to write a quick personal note of appreciation.

Final Thoughts

To wrap things up here a bit, much of what you pack will indeed be tailored to your specific needs. While I have covered a lot in this chapter, all of these items can be packed in a couple of good-sized duffel bags or other large-capacity containers of one kind or another. Don't let gear packing and organizing chores intimidate you. It's all part of the excitement of a new adventure!

◄ **Top:** Everything for an extended stay in the wilderness can be packed up into a very manageable load.

◄ **Bottom:** All this gear weighed less than 150 pounds and was no problem to take to the wilderness on a small bush plane.

4. Specialty Gear

As I mentioned in the previous chapter, there is some specialized gear that a photographer may choose to utilize for certain situations, depending on what and where one will be shooting. Before getting into more detail, keep in mind that animals differ quite a bit as far as their sensory ability, wariness, elusiveness, etc. For example, a wild Sitka blacktail deer may practically walk right up to you (or at least come very close) without a care in the world, no matter how you smell

▼ The level of wariness greatly differs from species to species. I captured these photographs of blacktail deer in completely wild, natural settings. They practically walked right up to me while I was unhidden and in the open. This would almost never happen with whitetail deer.

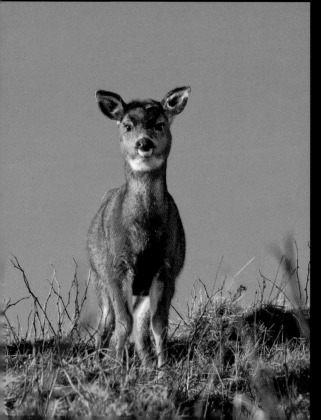

and what you are wearing. On the other hand, a wild and far more wary whitetail deer will be offended by your odor a mile away, detect your slightest movement, and be out of the area before you even knew it was there. Becoming fully aware of an animal's capabilities and what their dominant senses are is critical when doing your pre-field study. Based on this information, you can then prepare a strategy for making use of some of these more specialized items for a successful photo shoot.

▼ **Top:** In many cases, wearing solid-color clothing that matches the environment you will be photographing in is sufficient to help blend in.

▼ **Bottom:** Camouflage patterns come in a wide variety and can match any environment on earth. Wearing camouflage clothing can certainly give one a major edge while photographing wary animals.

Clothing Choices
Camouflage

Blending into the environment and minimizing your presence to a wild animal can be greatly aided with the use of camouflage clothing. While there are dozens of camo patterns out there to choose from, picking out an effective one is not so complicated. This is where more of your pre-field study comes into play. The essential idea is to pick out a camouflage pattern that matches the color, contrast, and visual texture of the environment you will be in. In many cases, one does not necessarily have to buy clothing with all the fancy camo patterns. Quite often, just having clothing with the proper natural color scheme of the environment is fine.

Ghillie Suits

On the other hand, in some cases it might be necessary to go beyond wearing patterned camo clothing and make use of what is known as a "ghillie suit." This is essentially an outfit made of blind or netting material that one then attaches or fills with natural debris from the immediate area. This could include grass, leaves, weeds, sticks, etc. Ghillie suits are used by military snipers in situations where they must be as invisible as possible. If one is photographing extremely wary animals, a ghillie suit can be an effective tool. They can be bought in a variety of pre-made colors, sizes, etc., or one can easily make one by simply buying some netting or blind material, cutting it to the size and shape of a rain poncho, and filling it with natural debris out in the field. Finally, don't forget to cover your face; that is often one of the first things by which an animal will visually detect you.

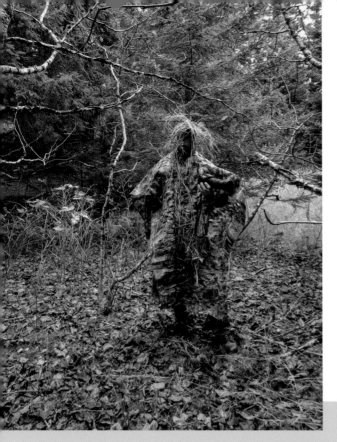
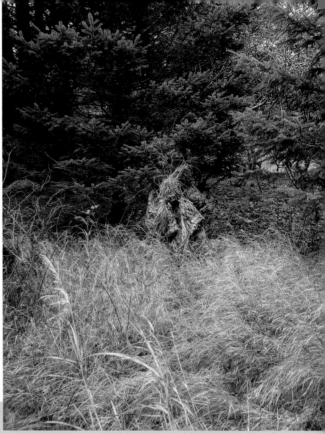

▲▼ A ghillie suit will make one virtually invisible. I made the one pictured here in less than five minutes by simply stuffing a piece of blind material with natural debris that matches the color, contrast, and background of the area, and draping it over me like a rain poncho. I'm purposely not staying completely hidden in these photos for the sake of visual instruction, but you get the point. Ghillie suits are especially effective in areas where there is not substantial natural cover to hide behind.

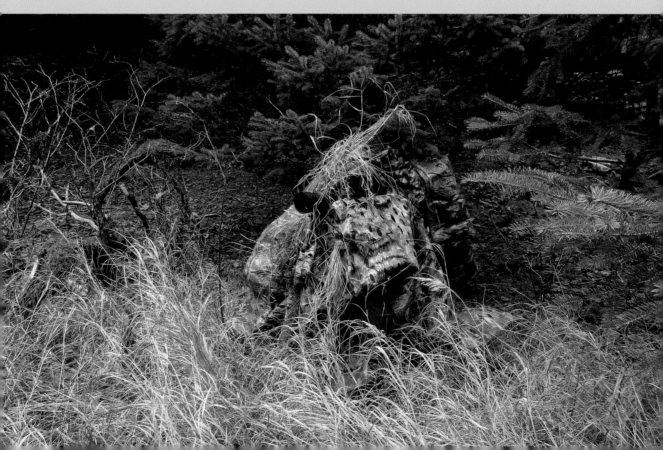

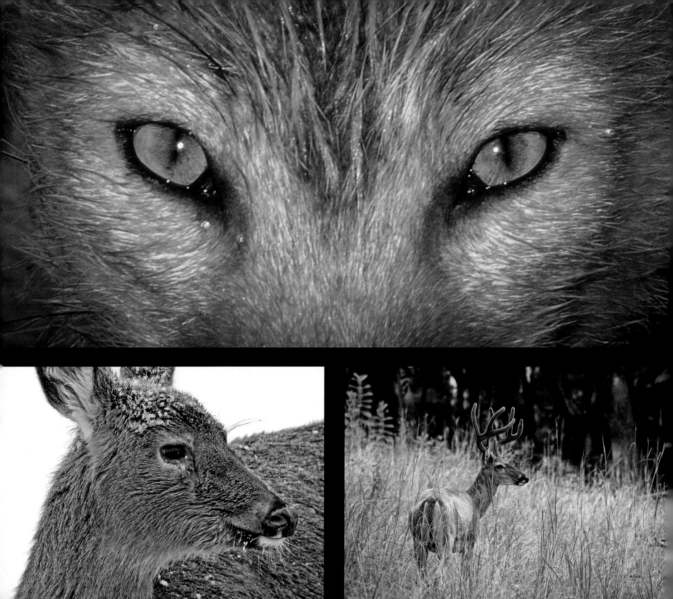

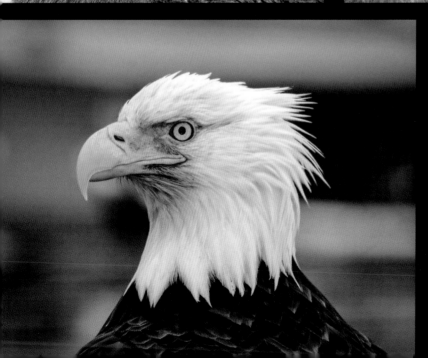

▲ ▶ **This page and facing page:** You never know when your photography subjects are watching you! Blending into the environment by utilizing the proper clothing is a great advantage.

▼ I photographed these brown bears on a cold, snowy, early spring day. Having a heavy-duty shell layer of clothing was critical.

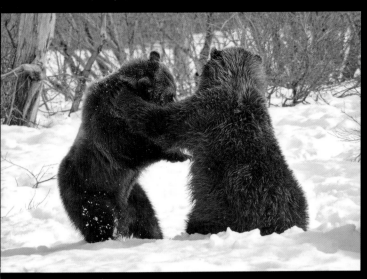
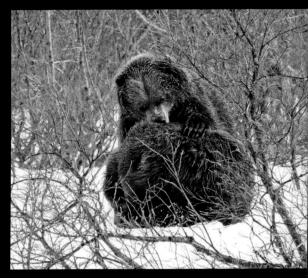
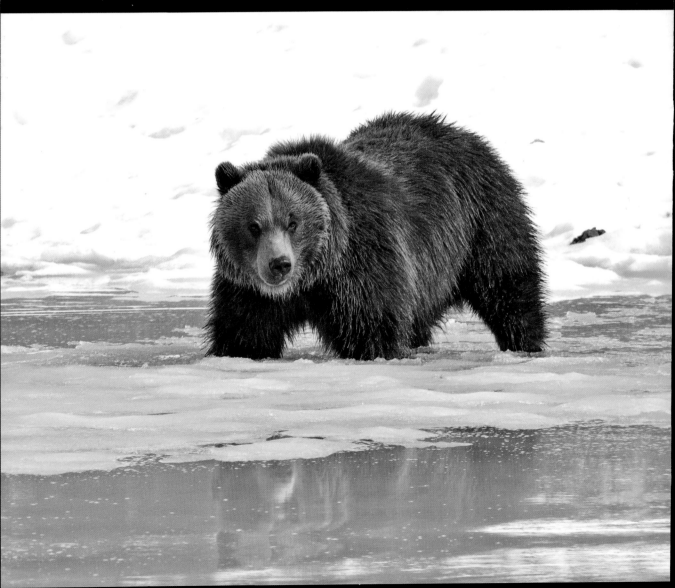

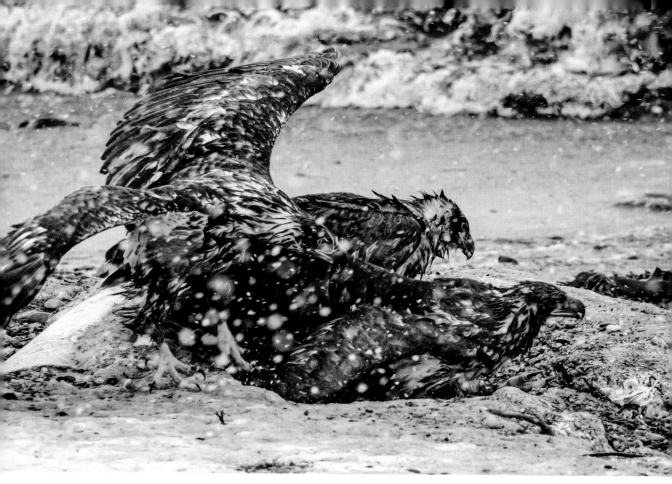

▲ The wind was brutally howling the morning I photographed this eagle wrestling match. The thick polyester shell layer I was wearing was not by any means made from "'quiet material," but with all the wind noise going on, it made no difference to the eagles who had no idea I was only fifteen yards away.

Minimizing Sound

No matter what you choose to do as far as camouflaged clothing, whether it's simply wearing garments with solid, natural colors, utilizing clothing with camo patterns, or going to the more extreme measure of a ghillie suit, another important clothing characteristic is that of silence. Most quality camouflage clothing that can be purchased at an outdoor store is made from "quiet" materials such as wool, fleece, etc. An easy test one can do while shopping is to simply scratch the garment. If it makes a loud, "scratchy" sound, try to avoid it and find something less noisy. This may be a little more difficult to do when shopping for a quiet "shell layer" of clothing, such as wind and rain gear, as those items tend to be made of materials such as heavy-duty polyester, nylon, rubber, etc. As I mentioned earlier, don't skimp on a shell layer, even if it is a little noisy. If it's windy and raining like crazy, it's going to be very noisy in the wilderness and most animals will be bedded down and inactive anyhow.

66 If it makes a loud, 'scratchy' sound, try to avoid it and find something less noisy. 99

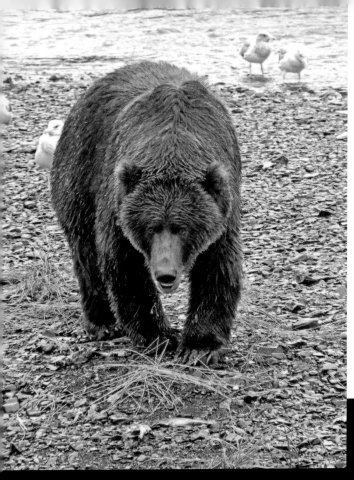

However, if the animal you will be photographing is active in windy, rainy environments, an option for silencing your noisy raingear is to wear a fleece jacket on top of your shell layer of clothing to keep it quiet. I have a fairly inexpensive, one-size larger, heavy fleece camo jacket that I bring along on trips strictly for this purpose. It works great!

Minimizing Scent

A final matter to consider when becoming the Invisible Man (or woman) is that of smelling invisible. The first and most powerful line of defense for many wild animals is that of their nose. Consider the fact that a whitetail deer has a nose as good as a bloodhound—and that a

◄▼ It was pouring rain the afternoon I came across this soaking wet Kodiak bear. Again, the noise produced by nature was more than enough to cover up the sound of my not-so-quiet rain gear.

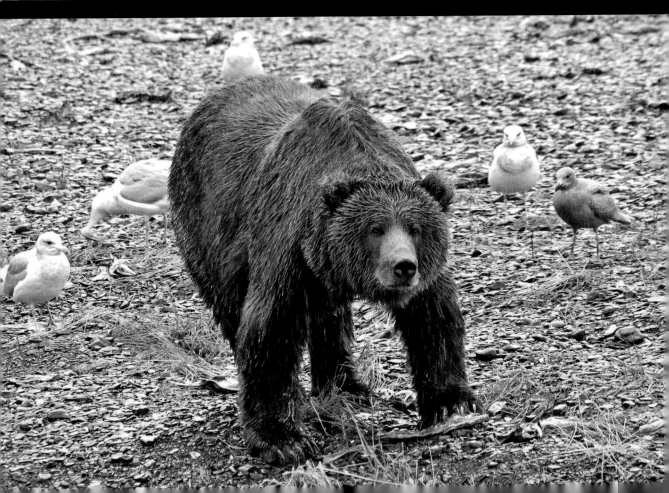

brown bear's sense of smell is *five times* stronger than that! Needless to say, if an animal with such olfactory superpower gets a whiff of you, which it can literally do from a mile away, your odds of photographing it are next to none.

Controlling and minimizing human scent is an area in which many serious hunters and wildlife photographers go to almost fanatical extremes. The level of intensity that one applies to their "scent-control system" will depend on the targeted subject, but controlling and minimizing human scent can be done in a number of general ways.

First, bathe with an antibacterial "scent destroying" soap/shampoo, wash your clothes in laundry soap made for hunting garments, and use scent-free personal care items. A huge variety of high-tech soaps, detergents, and scent-control products for hunters can be purchased at any outdoor/sporting goods store, but any generic cleaning product (for either your clothing or your body) that is scent-free, antibacterial, and devoid of any UV brightening agents will work fairly well. I tend to use simple products that contain baking soda, which has been used as a tried-and-true "scent killing" ingredient for generations.

Along with utilizing products that are intended to destroy human odor, an additional option is the use of "cover scents," which commonly come in the form of a naturally scented spray that you can apply to clothing or gear. Cover scents may smell like a variety of trees or other aromatic natural elements. Just as with picking out color-appropriate camouflage clothing, though, make sure to choose an appropriate cover scent. If you apply a pine scent to your jacket in an area that only has maple trees, the wildlife will know something is greatly out of place. Cover scents can also be

▲ Aromatic items found in nature are the best cover scents. Rubbing the scent into your clothing can greatly aid in blending into the environment and putting your photography subjects all the more at ease.

added in the field using natural materials. Simply rubbing aromatic tree branches, leaves, dirt, nuts, fruit, etc., on your clothing—or even rolling around on the ground and getting covered with the scent of the earth—can be a very effective method for applying natural cover scent. Just be sure you are not exposing yourself to rash-inducing leaves!

Another important practice is keeping your field clothing stored separately from your camp or travel clothing. What I often do is either hang my hunting/photographing clothes away from camp in some nearby brush, or simply keep them in a separate duffel or garbage bag filled with tree branches, leaves, and natural cover-scent items. The point is to keep human scents, such as excess body odor, food, smoke, etc., away from your field clothing as much as possible. And if your field clothes do become excessively sweaty or contaminated with scent from human activity, a last resort for helping to minimize it is to spray down your clothing with a "scent killing" product of one kind or another.

While implementing a good scent-control regimen is an important part of the photo-hunt experience, the absolute most important factor of all is to watch the wind at all times! Even though all the scent-control products and practices can certainly give one an edge at becoming invisible to an animal, they are not magic. I've had occasions where I utilized every conceivable odor-killing and cover-scent product and practice known to man, to the ultimate extreme, and *still* had wildlife detect me rather easily when the wind switched. The best and most important piece of scent-control gear that one can invest in (or make) is a small "wind checking" device, which is basically a small plastic bottle with some unscented talcum powder in it. Simply puff a little powder in the air, and bingo, one instantly knows exactly which way the wind is blowing, even when things seem dead calm. I can't stress enough how important and effective this simple little device is.

▼ Weather permitting, I like to hang and store my field clothing right in the field in order to air it out and absorb more of nature's aroma. Wearing or storing your field clothing around camp puts it in danger of becoming contaminated with all sorts of human and food odor, which can ruin a wildlife photo shoot long before it even starts.

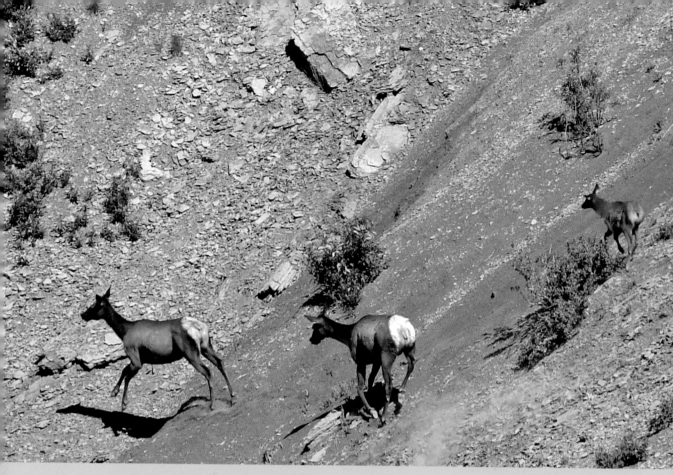

▲ A change in wind direction can abruptly end a wildlife photo shoot.

▼ A small wind-checking device is the best defense against an animal's nose. Keep it handy at all times, use it often, and try to stay downwind of your subject.

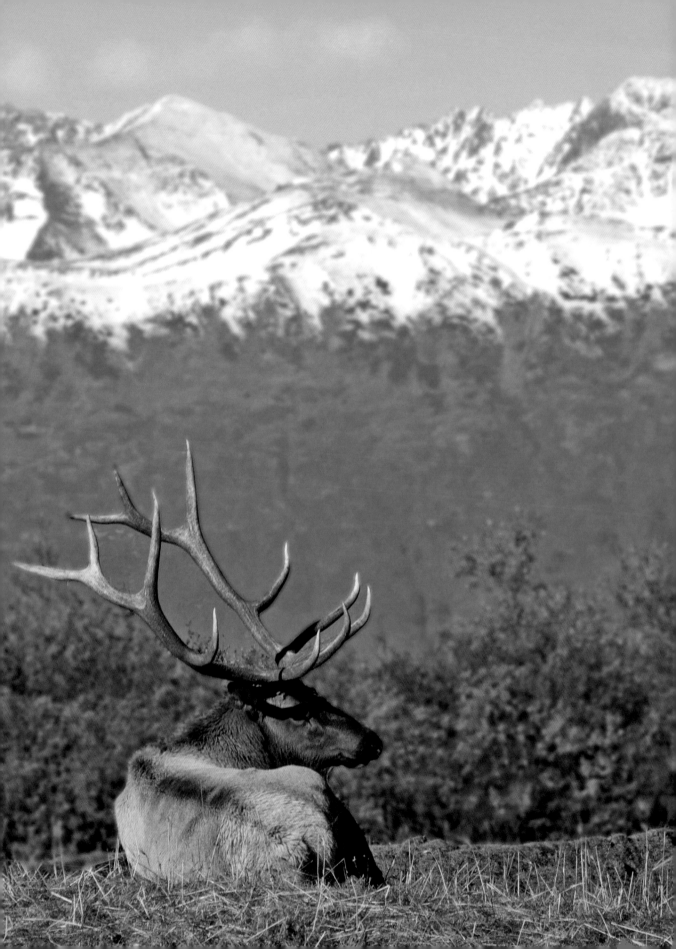

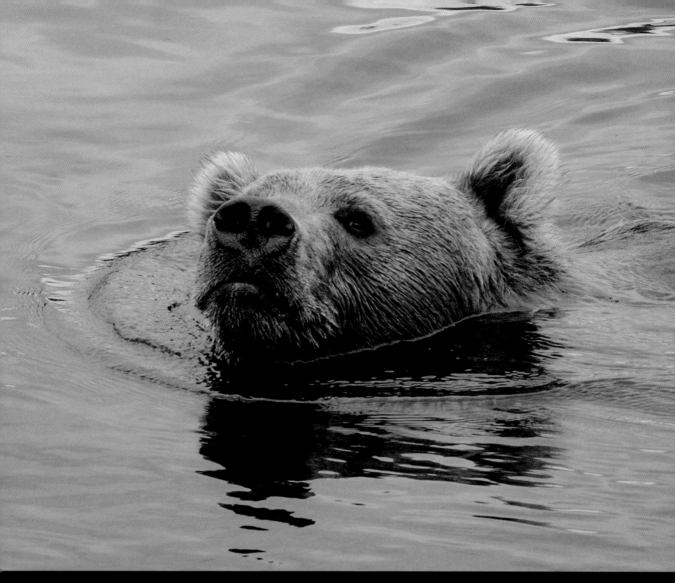

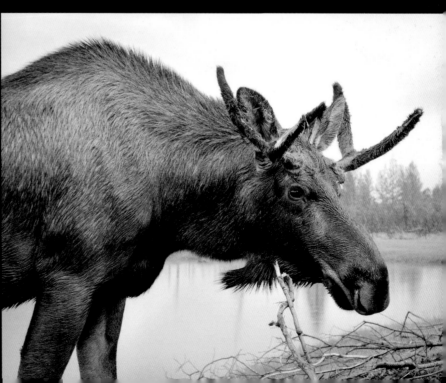

◄ ► **This page and facing page:**
There is almost no escaping the nose-power of such animals as bears, deer, elk, moose, and other creatures known for olfactory excellence.

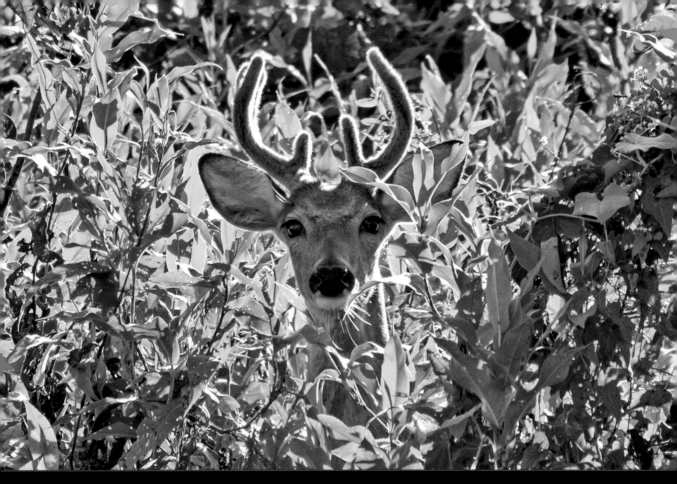

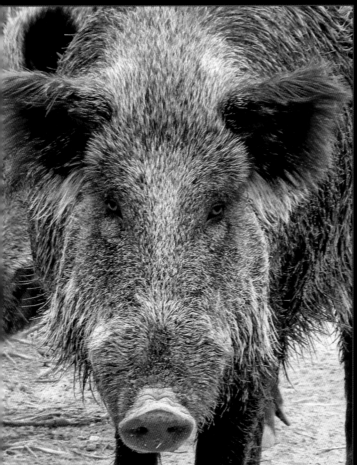

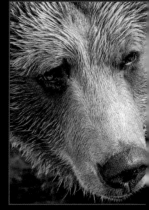

◄▲ Controlling one's odor is a top priority when photographing animals that are extremely well attuned to scents in their environment.

Making Your Gear Invisible

Along with making yourself as invisible as you can by means of clothing and scent control, another area of consideration is making your gear as invisible as possible. Try to minimize the loud sounds of zippers, Velcro, and snaps. When shopping for new clothing and gear, test these features to see how much noise they make and if they can be operated quietly. Also, avoid anything shiny, reflective, or that makes a ruckus when being operated or set up. Use flat, natural-colored paint, camo tape, or dull-colored cloth to hide and silence any "loud" gear. And finally, if your camera has a shutter silencer, use it!

Photographer Concealers

For getting wildlife to within good camera range, there are a few other specialized items to consider utilizing in the field.

Blinds

Blinds are a highly effective tool for keeping yourself well hidden from the subject while

▶ A natural-colored or camouflaged umbrella and a stash of blind-making material can aid in constructing homemade photography blinds.

▼ A piece of blind material stretched between two trees or bushes can be set up, or taken down, in just a few minutes. Finish it off by weaving in twigs, small branches, grass, and weeds to give the blind an extra element of realism. For instructional purposes, my blind can easily be seen in this photo. When setting up a blind for genuine use, make sure it matches the color, contrast, and background of the particular area.

▲ **Top, left and right:** In many remote settings that have roads, a vehicle may be the only blind one needs. Most animals in such areas are used to seeing cars and trucks and are not frightened by them – at least from reasonable distances. A window-mounted camera rest is a great tool to have in one's wildlife photography arsenal.

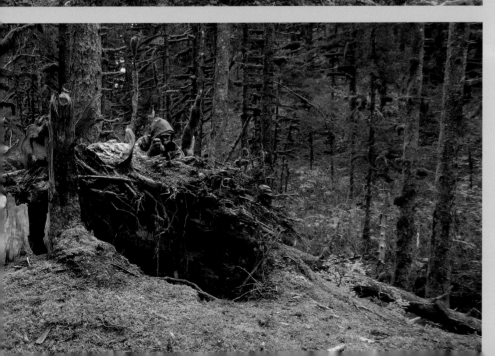

◀ **Left, top and bottom:** Mother Nature provides plenty of fantastic photography blinds. Dead trees and root wads, as pictured here, are great places to set up in for a photo shoot. Can you spot me in these photographs? Most animals would not either.

photographing. If you have a lot of gear and are going to be doing a fair amount of moving around during the photo-shoot, such as changing lenses, etc., a blind will do just what its name suggests: it "blinds" the animal from seeing all the commotion. Portable hunting/photographing blinds come in many sizes, shapes, colors, etc. They can be as complex as an entire tent-like structure, as simple as a big, camouflaged painted umbrella, or a piece of blind material stretched in-between a couple of bushes to sit down and hide behind. Visit a store that sells hunting supplies and you will find plenty of options for blinds and blind-making materials. If you are going to be photographing in an area that can be accessed by a vehicle, a car or truck may be all the blind you need. (*Note:* If shooting from a vehicle, a window-mounted camera rest is a great piece of equipment to invest in.)

Blinds can also be easily made with what nature provides. Nestling into a bunch of dead-fallen trees, a big pile of sticks and leaves, a riverbank with tall weeds, or a mound of snow, dirt, or sand is often the perfect, most natural way to keep one hidden while photographing. And if those sort of things are not present at the optimal locations for photographing, simply collect some natural debris (tree limbs, weeds, etc.) and fashion a simple

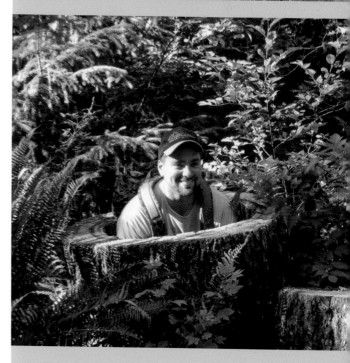

structure to hide behind. Whether homemade, natural, or commercially manufactured, the important thing is that the blind matches the terrain you are working in. Just like with choosing the proper camo pattern or cover scents, if you have a blind that does not fit the target environment, it becomes a visual repellent.

Tree Stands

Another highly productive option (depending on the location and intended subject) is the use of a tree stand. Being perched well above the ground gives one an advantage for scouting

◄ Portable tree stands, climbing devices, and safety harnesses come in a variety of sizes, shapes, and models. Do some research on the options, legality, and safety of each before using a tree stand in your intended photography area. Also, take the time to practice using each component well in advance of your photo shoot.

▼ A well-placed portable tree stand can make you completely undetectable to your photography subject. Can you see my tree stand in this photo?

out and photographing animals. It minimizes human scent detection, allows one to get away with more movement, and also provides an opportunity for unique, high-angle shots of the subject. Not to mention, it's fun to sit up in a big tree all day . . . unless you have a fear of heights!

Tree stands, like blinds, come in a variety of models—from huge, hotel-room sized, more permanent fixtures to small, packable units that can be set up, taken down, and moved around quite easily. Visit a store or check out a catalog that sells deer-hunting supplies and you'll find all sorts of options for tree stands. A word of caution, though: tree stands can be very dangerous! If you plan on using one, be sure to do your homework. Research each style and check the safety ratings. Then, practice setting it up, using it, and taking it down many times before use in the field. Most importantly, purchase a top-quality safety harness to go with it. Every year, many deer hunters die or get seriously injured simply because they did not use a safety harness and fell out of a tree.

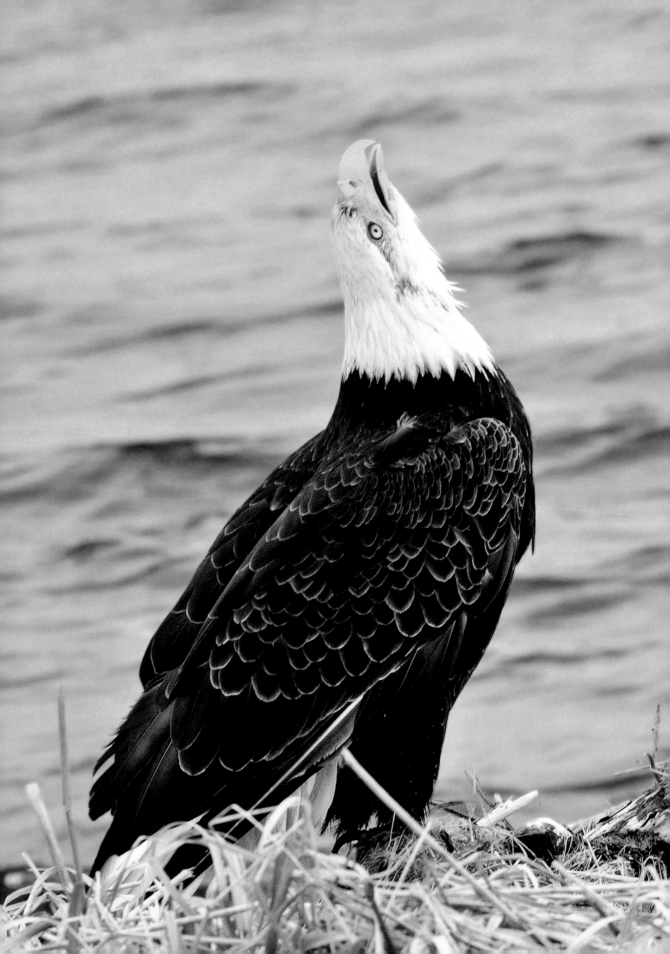

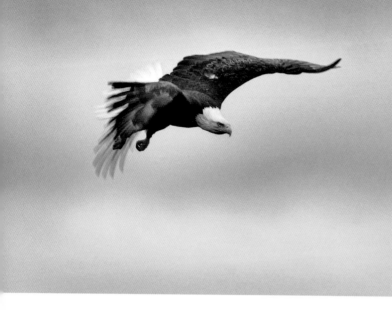

◄ **Left and facing page:** Predatory animals such as eagles can be called into camera range with minimal effort.

Animal Attractors

Animal Calls

Animal calls can be incredibly fruitful in getting great wildlife photos. Depending on the species you intend to photograph, having a working knowledge of how an animal communicates, and being able to imitate those sounds with a calling device of one kind or another, can produce astounding results when used in conjunction with good camo, a blind, etc. I've called turkey, deer, moose, elk, bear, coyotes, foxes, eagles, owls, and many other animals literally almost right into my lap with the use of well-practiced calling techniques. Remember, too, that not all calling techniques are based on the sounds an animal makes through its mouth. Many sounds that lure in wildlife are the sounds made while fighting, searching for food, the distress of prey animals that become dinner, etc. Learning basic calling techniques for the animal you wish to photograph can go a long way in producing fantastic photographs.

Decoys

In conjunction with animal calls, a decoy can also be useful for attracting certain animals— or at least bringing them into camera range. Lightweight, collapsible, and packable animal decoys are widely available today. Decoys and realistic replicas of animals as big as a cow elk or as small as a mouse can be purchased from stores that sell hunting goods, gardening supplies, pet and pest control products, and even toy stores. Anything that resembles a target animal, its food, its mate, or its enemy can be effectively used as a decoy. A decoy does not have to be fancy or highly detailed, either. Anything that has the shape, color, and size of the animal being represented will often work. I've

▼ These calls can imitate the vocalizations and auditory activity of many different animals.

seen very effective decoys made from a simple piece of cardboard or plywood. Sometimes, all it takes to visually lure in an animal is to simply flash a certain color through the bushes in sight of the target species. For example, a white rag can imitate the flick of a deer tail or the flash of a moose antler. You can get quite creative when it comes to decoys.

Scent Lures

Appealing to an animal's sense of smell is another powerful method of attracting it to

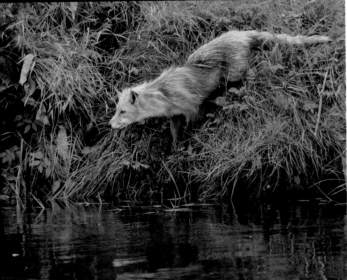

▼ Predatory animals such as bobcats and foxes can be called into camera range with minimal effort.

within camera range. Along with calls and decoys, a large variety of scent lures are on the market for hunters, trappers, and pest-control professionals. These scents may imitate favorite foods, trigger sexual attraction, or mimic the scent of a rival creature. The proper use of scent lures, along with implementing calling and decoying techniques, is something to study in detail before attempting it in the field.

Caveat

Before you even *consider* using animal attractors, check on the legality of these things for the intended location. Additionally, animal calls, decoys, and scents should never be used in a harassing manner while photographing. Not only is intentionally getting a wild animal overly excited, angry, or hungry a disrespectful act, it can also have very dangerous results. Again, in-depth study of these subjects is essential for proper, safe, and effective application.

As a final note in regard to scents and attractors, don't even think about using real food or "bait" for photography purposes. While baiting is legal in some situations for hunting purposes, where an animal is ultimately going to be killed and eaten, it is totally unacceptable for photography. If a wild animal is fed by humans, it begins to associate humans with an easy food source. This results in very bad and dangerous habits such as raiding camps, coolers, trash, etc. In many cases, animals that become accustomed to human food become a nuisance and have to be killed. So please do not feed wild animals! Keep them wild and safe by letting them find wild food in the wilderness. In fact, as we'll cover later, photographing animals at their natural food sources is far more effective anyway.

As we have seen, there is a great deal of work to do and many considerations to be made before heading to the field—especially for remote, extended stays in the wilderness. I'd like to now focus more specifically on the personal, individual preparations that apply to the photographer who will be targeting wild animals in wild places. Once again, let's begin with a reality check.

The Price of Success

Capturing world-class wildlife images certainly comes with a price. Along with the steep expenses of traveling, photography equipment, and the hours of invested time it takes to produce quality images, there are also more personal debts to pay. One may have to endure extreme weather conditions, camp out in areas of remote wilderness that are only accessible by bush plane or boat, be eaten alive by hordes of blood-thirsty bugs, crawl through areas loaded with horrific, thorny, rash-inducing plants, fall in rivers and lakes, get stuck in swamps, lose hours of sleep in races against the rising sun, become exhausted beyond belief while climbing and hiking for miles upon miles in treacherous terrain, be in close proximity of very dangerous animals, and . . . well, you get the point! As I often remind folks, serious

▶ Getting out to the wilderness, in and of itself, can be expensive, exhausting, and dangerous—but it's all part of the adventure of wildlife photography.

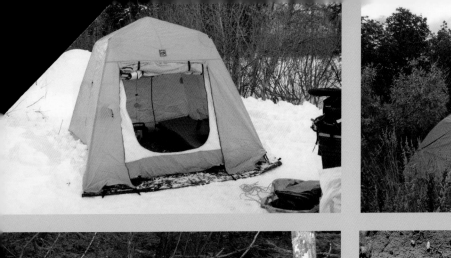

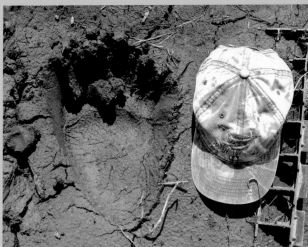

▲ It's not necessarily fun camping out in subzero temperatures, in the middle of bear-infested jungles, or in tiny, uncomfortable, spike-camp tents. A wildlife photographer often makes many sacrifices that are not known or appreciated by his or her customers and clients.

wildlife photographers willingly put themselves through all sorts of half-crazed rigors in order to capture the elusive art of the natural world. The art of wildlife photography often comes with great sacrifice on the part of the artist, which many don't realize or carefully consider as they look at the price tag or copyright laws of one's work.

Practice Makes Perfect

"Prior preparation prevents poor performance" is a phrase that applies to many things in life, and it most certainly is a creed that must be embraced by a wildlife photographer. Everything that one does in the way of preparation,

from pre-field study and diligent gear organization to getting physically fit and mentally ready for a photo adventure—it all leads up to the moment of truth when a magnificent creature is in focus and one's finger is about to press the shutter button.

Know Your Camera

As I mentioned at the beginning of this book, a prerequisite for serious photography of any kind is to know your camera inside and out— to have full command of the camera's features and capabilities. The photographer must be able to quickly and effectively make changes to the camera's settings in order to capitalize on

those elusive moments and once-in-a-lifetime photo opportunities. You must be able to improvise, adapt, and overcome in any challenging situations that may arise, as they often arise very quickly and unexpectedly. I have to admit, it blows my mind when I encounter individuals who have invested a very large sum of money in traveling to rather exotic locations to explore and photograph the area, and yet have no idea how to use their camera other than simply shooting in the automatic mode.

After taking the time to thoroughly know your camera's capabilities, it is extremely important to do lots and lots and lots of practice with it. As a hunter must possess deadly proficiency with his weapon of choice to quickly and humanely harvest a game animal, a photographer must also be equally skilled with his or her camera. And the only way to achieve such a high level of proficiency is by disciplined, diligent practice—and lots of it!

Go out and shoot everything in sight with your camera! Shoot in different weather conditions, at different times of day, with different lenses, using different camera settings and features. Shoot both moving and stationary subjects. Keep blazing away relentlessly until you can anticipate what will happen and what kind of image your camera will produce in any given situation. Take notes and keep track of what camera settings you can shoot best with. Keep practicing until you have total confidence that you can successfully handle any given photographic situation that you may encounter. A hunter will fire hundreds and even thousands of rounds with a firearm or bow in preparation for that one shot that will matter most, and a serious wildlife photographer must do the same with the camera.

Know Your Subjects

Upon truly mastering your camera gear and racking up the necessary hours of general practice, it's time to move on to wildlife photography training. As you are getting ready to photograph a specific animal in the wild, I'd recommend first doing some practice on subjects that will be more tolerant of your presence, and in areas that will not require the Coast Guard to rescue you in case of an emergency. Go to your local zoo or, if possible, to a

▼ Simply taking pictures is a small part of the total equation in nature photography. Being willing to boldly venture where few others go is a must.

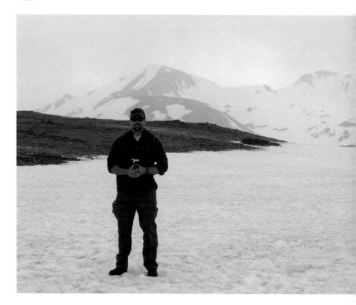

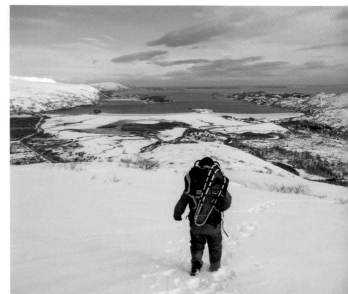

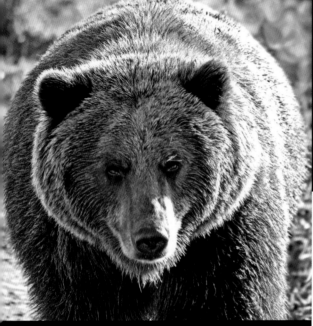

◄▲ This page: Before I started photographing big bears in the wild, I made it a point to get lots of practice shooting bears at conservation and wildlife refuge areas, where the bears were habituated to humans and there were safe, designated viewing areas.

► Facing page: Many of the wildlife photographs that are seen in popular magazines and advertisements are shot in national and state parks, areas where the animals are fairly used to seeing people.

conservation area, wildlife preserve, or an easily accessible national or state park where you can watch and study animals for many hours in a safe, semi-controlled environment. Getting familiar with how a certain animal looks in different lighting conditions, how it moves, how it interacts with other animals, how it eats, drinks, etc., will get you prepared for what to look for when photographing in the wild. It will also give you ideas of particular scenarios you'd like to capture with your camera. If the specific animal you intend to photograph cannot be found in these more tame settings, then try to practice on similar animals—or at least an animal that is in the same biological classification. The point of this more specified, realistic photography practice is to continue to develop the "eye" for composition, lighting, visual flow, etc., as it applies to wildlife photography and to develop an instinctual anticipation of the shot.

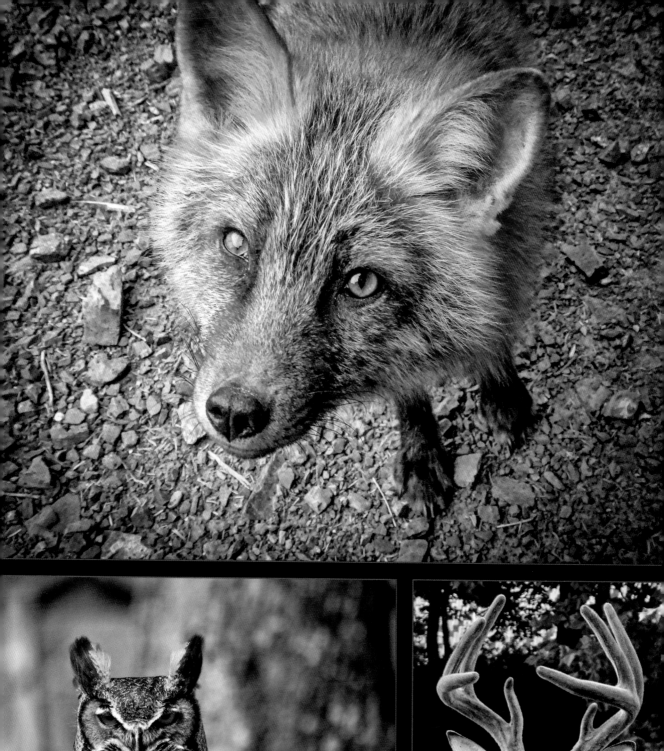

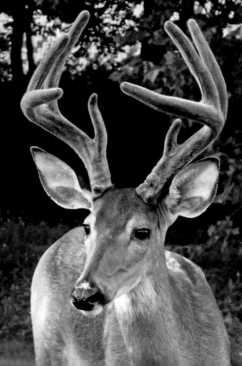

Facing page: National and state parks are great places to practice your photography skills, and they can produce some wonderful images, such as these.

This page: Livestock or feral animals are also great to practice on. Beware, though; some of these animals can be protective, aggressive, and dangerous. One must always be respectful and cautious while photographing any animal, no matter how wild or seemingly tame.

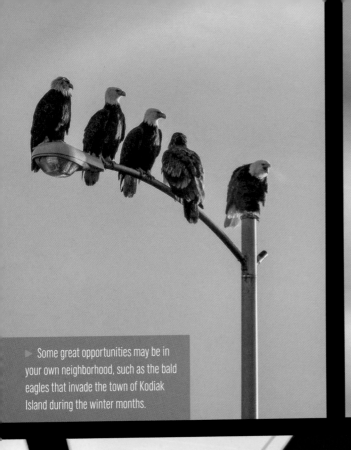

► Some great opportunities may be in your own neighborhood, such as the bald eagles that invade the town of Kodiak Island during the winter months.

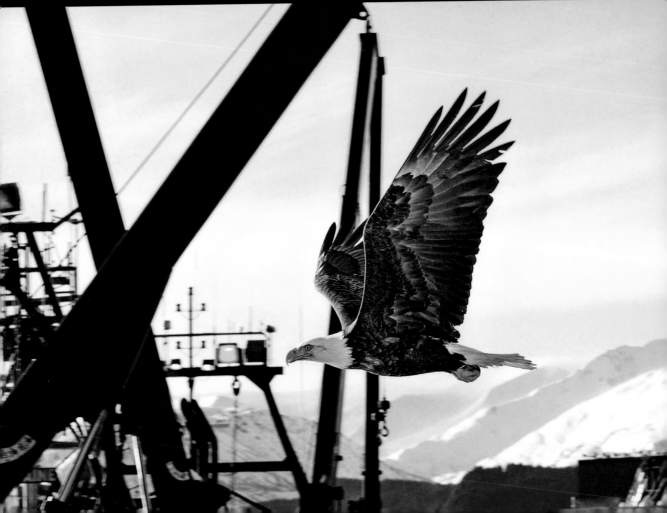

Train Your Mind

Along with disciplined practice with one's camera, the wildlife photographer will also have to undergo a fair amount of mental conditioning to be consistently successful in getting the kinds of images one is after. As I mentioned earlier, it is no easy task to get world-class photographs of wildlife. The general public often has no idea of the sacrifice a photographer makes to capture and create amazing images of wild animals. Along with doing all the study and research, preparing gear, traveling, enduring the rigors of the wilderness, and all the other factors, an especially difficult part of it all, for many photographers, is having the mental discipline necessary for success.

While there are certainly times that incredible photographic opportunities come easily and just magically happen with very little work or effort on the part of a lucky photographer, this is usually not the case. In most situations, a wildlife photographer has to create his or her own "luck." I've always liked the definition of luck as, "An instance in which skill and opportunity meet together at the same time." And, really, that's the whole point of this book: to help you be totally prepared for and able to seek out great photographic opportunities— and to have also developed an awareness of the skills and tools necessary to make the most of a great opportunity. But lucky or not, the reality and price of success is one of sacrifice.

The mental discipline that a wildlife photographer must acquire is one rooted in extreme patience, perseverance, and stillness. One of the major negative results of living in our noisy,

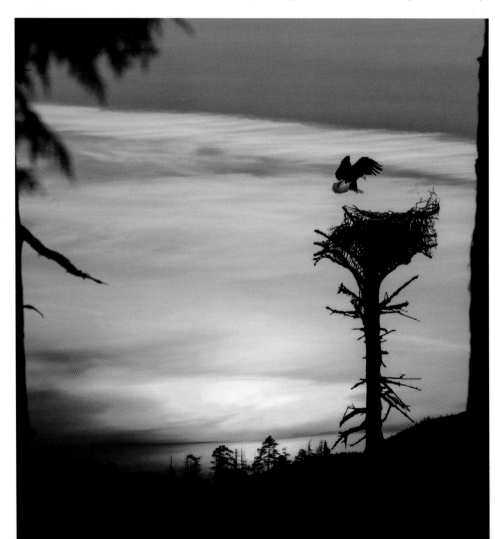

► Exercising extreme patience is eventually rewarded by capturing the elusive moments one is after.

high-speed, multimedia, sensory-overloaded culture is that our attention spans are getting shorter and shorter. We live in a world where many individuals are almost surgically attached to their smartphones, fiddling with entertaining apps and gawking at a tiny screen at every moment of the day, being subjected to constant, low-grade mental stimuli. Everywhere we go in our modern society, our senses are bombarded with background music, flashing lights, signs, high-definition everything, huge plasma screens, etc. For most folks these days, the idea of sitting quietly (or even in total silence) for

hours and days on end with no intentional, external distractions of any kind sounds like some sort of cruel torture. But this is what is often necessary to capture images of extremely elusive wild animals in their wild habitat.

There is no easy way to develop an exceptionally high level of patience, to summon forth the ability to persevere though challenges of all kinds, and to be able to consciously keep both the mind and the body as still as a blade of grass on a windless day. But these are the qualities a successful wildlife photographer must develop. The only way to attain these virtues is to exercise them—just as one must exercise the body to stay fit and get stronger and healthier. There is no magic pill you can take to instantly possess a superhuman level of patience, perseverance, etc. You must simply make the willful, conscious decision to be more patient than the day before, even if it's just a little bit. You must willfully choose to tough out a difficult situation and continue to persevere, even if it's just a few more minutes.

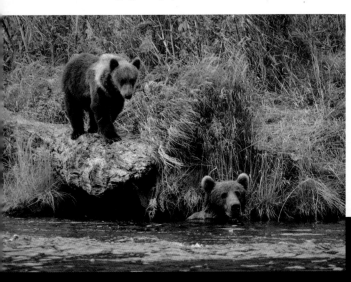

◄▼ Exercising extreme patience is eventually rewarded by capturing the elusive moments one is after.

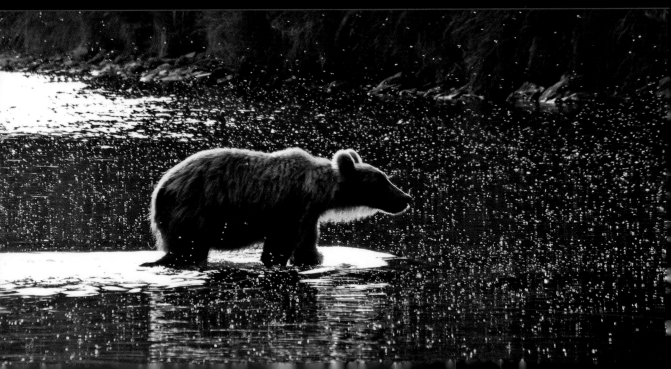

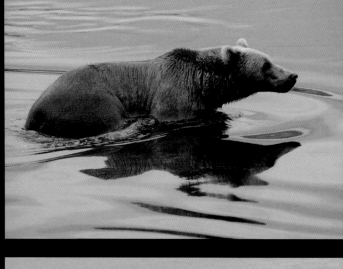

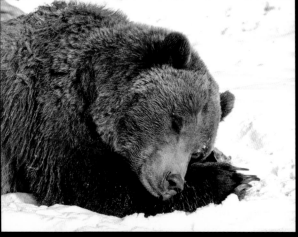

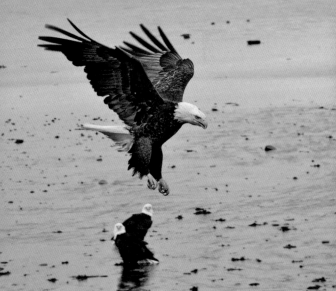

▶ ▲ I had to wait many hours to capture images such as these. Holding out for an animal to make a certain bodily movement, facial expression, or gesture can be mentally exhausting! But these are the images that are cherished the most, when it's all said and done.

Just as a runner improves by willfully choosing to run that extra lap or mile, a wildlife photographer enjoys more success by consciously deciding to stay put for another hour while waiting for an animal to come out of hiding, or hiking a little farther into the wilderness to find a more prime shooting location. Making those willful, conscious decisions that lead to an improvement of mental discipline, no matter how small the improvement may be, is what eventually pays off in a big way.

I will certainly admit, it's just plain hard to be still and quiet while sitting up in a tree or nestled into a patch of tall grass all morning, noon, and night just hoping for that awesome wildlife encounter to happen. It's even more difficult when it's freezing cold, windy, and rainy. Throw in a batch of pesky insects buzzing around your head all day, and your patience will really be put to the test! But when that magic does happen—when you get the most incredible images you could ever imagine, when you are able to immortalize and share that moment with the world by means of your photography—all the hours of misery simply vanish.

6. Scouting

When a wildlife photographer finally gets out in the field to begin exploring the area and searching for the particular animals he or she is after, all that prior preparation genuinely begins to kick in—and it does truly prevent poor performance. The more you have studied the targeted subject's habits and behaviors and know what to expect in a particular environment, the more quickly and confidently you can get right down to business. Keep in mind, though, that putting all your armchair knowledge to work out in the field is still a challenging task, but it's an exciting one! It's quite a thrill when you put together all the pieces of the puzzle, from start to finish, in regard to finding and photographing wild animals in their natural habitat.

A Big Time Investment

A hunter who is trying to find and harvest a game animal in a totally new, unexplored area will often spend up to two-thirds of his time afield scouting out the prime locations in which he will then focus the majority of his efforts. The same holds true for those who do their hunting with a camera. The wilderness can be a big, confusing, intimidating place—and trying to find the animals you are after can often be like trying to find a needle in a haystack. Scouting in the field is essentially a process of elimination. In order to find the areas with the best photographic opportunities, you have to keep factoring *out* the areas that do not have the potential or the tell-tale, fresh sign of an animal's presence. In doing so, you will eventually find those primary areas of actively used habitat that an animal calls home. It's those locations on which you can then really focus your photographic time and attention.

Hiring a Guide

Because of the time involved in thorough scouting, many photographers (as well as hunters) cough up a few extra bucks and hire a guide. If you don't necessarily want to spend over half your time in the field searching high and low for a few hot-spots in which to photograph, a guide really pays off. A good guide— one who knows a particular area of wilderness like the back of his hand, who is intimately familiar with the location and habits of the animals you are after, and who will take care of a majority of the camping or travel chores—can help make the most of your experience in the

▼ Be comfortable and confident with those you may be venturing into the wilderness with.

field, to say the least. While some thoroughly enjoy the "self-guided" experience and take satisfaction in being able to do it all themselves, others want to cut right to the chase and start getting good photographs as soon as possible, instead of burning up hours upon hours with scouting and camping activities.

Before hiring a tour service or guide for a wildlife photography adventure, it is important (once again) to do your homework. Spend some time checking out the guide's background. Try to find references and reviews. Talk to people who live in that person's community who can give an honest, unbiased opinion. The local chamber of commerce or travel bureau of a particular area can often be the best place to start. Prepare a list of questions you can use to interview a potential guide before you hire him or her. Don't forget, you are putting your life in this person's hands in many ways, so be sure that the potential guide is someone you feel comfortable with.

Likewise, if you are simply hiring someone to take you in and out of the wilderness (such as a bush pilot, charter boat captain, etc.) do a background check on that person or service provider. Make sure they have a good safety record, are reliable, and responsible. Some of the folks you may meet in remote locations who hire themselves out to provide such services might not be the best folks to do business with. Ever seen the movie *Deliverance*? Need I say more? Make sure the people you hire to help you are reputable professionals.

Tabletop Scouting

As I mentioned in a previous chapter, it is vitally important to do as much "armchair hunting" as you can before heading out to the field. The more you know what to look for (as far

▲ Becoming intimately familiar with an area of wilderness you intend to photograph in before you actually get there is a huge advantage.

as fresh evidence of an animal's presence) and where to begin looking for it, the faster you can get to the task of taking pictures.

Topo Maps and Aerial Photos

A preliminary step that can save you lots of excessive scouting time in the field is the thorough home study of a quality topographical map or aerial/satellite photos of the location you will be in. If you can't easily get highly detailed topographical maps of your intended location, then I recommend www.mytopo.com, a fantastic service that will help you create your very own custom topo maps. Another great tool that can be used in conjunction with a quality map is Google Earth, which provides aerial/satellite photos of, well, anyplace on the planet. Using a topo map along with aerial photos can help tremendously in getting a good feel for the land, long before you step foot on it. I like to have a print-out of both the map and the photo handy for home study, as well as in the field. Having a set of different-colored highlighters is also a good idea for color-coding your map while doing an in-depth, tabletop study.

Identify Potential Hot-Spots

When using maps and aerial photos for scouting purposes, you can immediately see the

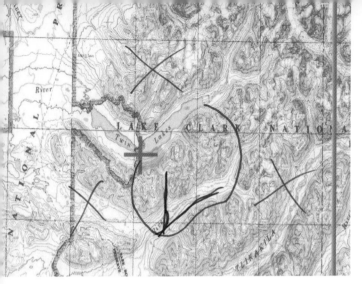

▲ Color-coding your maps is a great way to study and consciously focus on prime locations to explore when actually getting to the field.

big picture from the comfort of your kitchen table. I like to first identify areas on the map that would pretty much be a waste of time; I outline or cross out those in a particular color. Next, I'll look for areas that could potentially be good bedding, feeding, and watering areas, as well as possible travel routes for animals. I'll mark all those in different colors, as well. Based on what I learned from careful study about an animal and its preferred habitat from all the different sources I covered earlier in the book, I'll mark and highlight my map and aerial photo accordingly to reflect all potential hot-spots to visit when I get in the field.

After really honing in on prime areas for my photography efforts and clearly identifying them, I then like to pick out a couple of potential spots on my map to set up camp. A quick word of caution, though: make sure your camping area is well away from your photographing area. Wildlife will not stick around for long if they detect your presence—and don't forget that some animals can literally smell you a mile away.

As a final step in my tabletop scouting, I mark my potential photography hot-spots and camping locations on Google Earth, or other mapping software, and load those coordinates into my handheld GPS unit. When I then get out in the wilderness, I can fire up my GPS and go right to all those different locations with much less effort than trying to figure it all out from scratch in the field, resulting in hours and days' worth of wasted time. As a final bit of advice, as I briefly mentioned in an earlier chapter, I recommend learning how to navigate with a quality compass and map as well as a GPS unit. I'll say it again: don't trust your life to gizmos that run on a few little batteries. Gadgetry is not a good substitute for skill.

Field Scouting

The scouting you do by means of thoroughly studying quality maps, aerial photos, etc., will give you a tremendous jump-start on the scouting you need to do in the field. Once you have identified those potential hot-spots on your map and actually get yourself out to those physical locations, it's time to start doing some careful investigation in order to really pinpoint the prime photography areas.

As you will learn from your careful pre-field study, animals leave all sorts of signs as to their

▼ Picking out locations on your map for potential camping spots can save a lot of time and headaches.

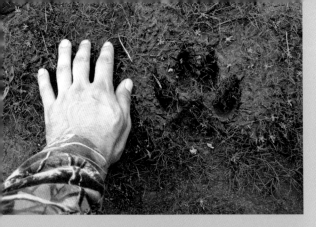

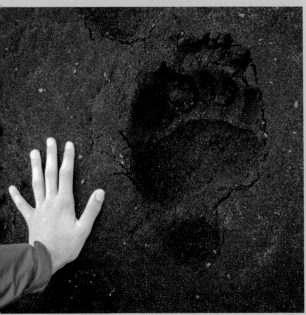

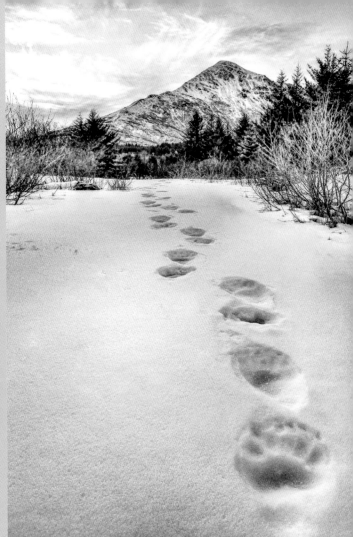

▲ Fresh animal tracks, both big and small, are easy to spot. Fresh tracks are usually the first and most obvious sign of an animal's presence.

presence and activities, just as people do. Walk into a human being's house, and you can clearly see where they eat, sleep, go to the bathroom, recreate, etc. Depending on the person's habits, it's fairly easy to tell if they have been home recently, what they like to eat, when they last ate, took a shower, etc. Likewise, wildlife leave some pretty obvious indications of their whereabouts and activities. Naturally, those vary greatly from creature to creature, and one will need to know what to specifically look for in regard to a specific animal.

Tracks, Scat, and Food

Every kind of animal in nature leaves tracks. Knowing what they look like and being able to tell how fresh they are is the first major thing you can look for and find without too much trouble. Along with that, every creature in the wild goes to the bathroom . . . some go quite a bit. Knowing what a particular animal's scat (poop) looks like can reveal a great amount of information, such as the approximate time the animal was there, its size, sex, and very importantly, what it has been eating.

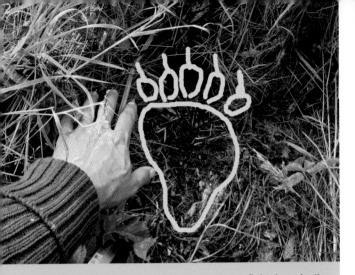

▲ Some tracks may not be so obvious. Learning how to find and examine the freshness of hidden tracks is a valuable skill to practice.

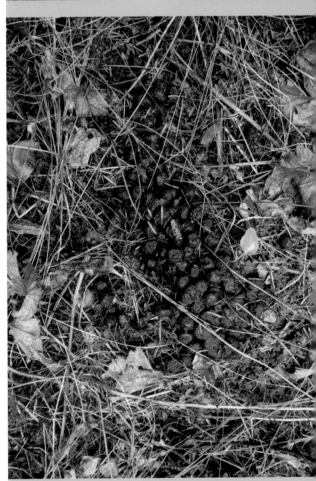

▲ Areas where there are tracks from several different animals are prime locations to focus on photographing. I found fresh bear, deer, fox, eagle, and ermine tracks all on this same area of river bank.

▲ It may seem a bit gross, but actively searching for fresh animal scat reveals an animal's presence and what that animal has been eating. Find the food and you will find the animal you are after.

If you can clearly identify what an animal has been chowing down on regularly, you can then focus on perhaps the most important piece of the puzzle of all: food! The number-one factor for finding wildlife of any kind is to follow the food! Find out what the available and preferred food sources are for a particular time of year and where those sources are most abundant and readily accessible, and I guarantee you will find the critter you are after.

▼ Finding the fresh remains of primary food sources is another tell-tale sign of an animal's immediate whereabouts.

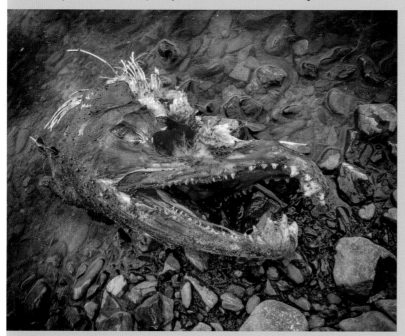

▼ Fish bones in this bear scat tell me what's been on the menu.

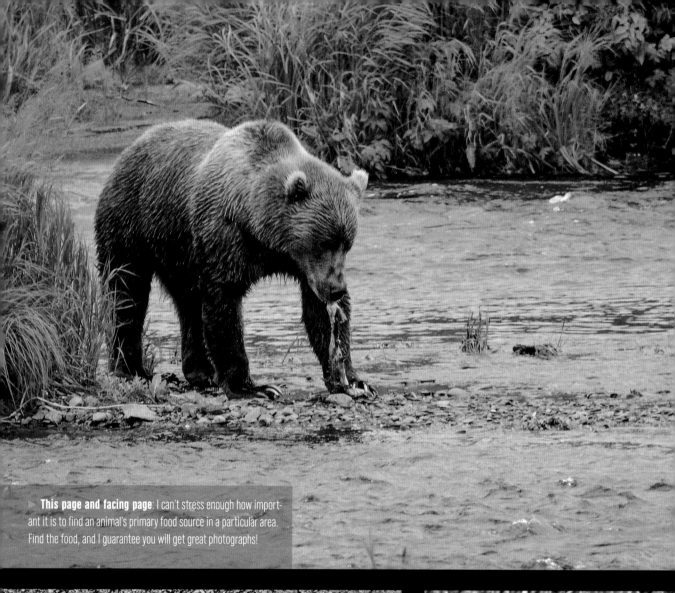

> **This page and facing page**: I can't stress enough how important it is to find an animal's primary food source in a particular area. Find the food, and I guarantee you will get great photographs!

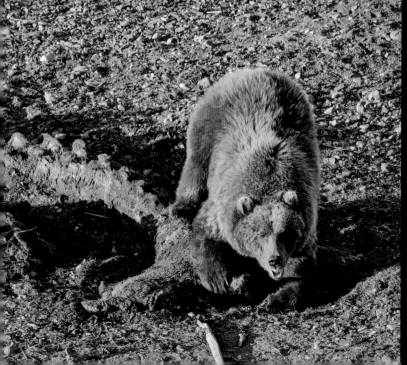

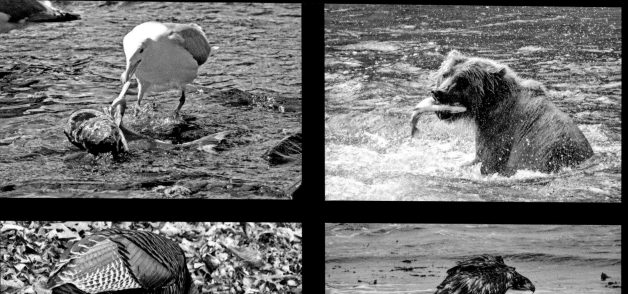

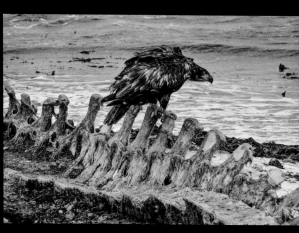

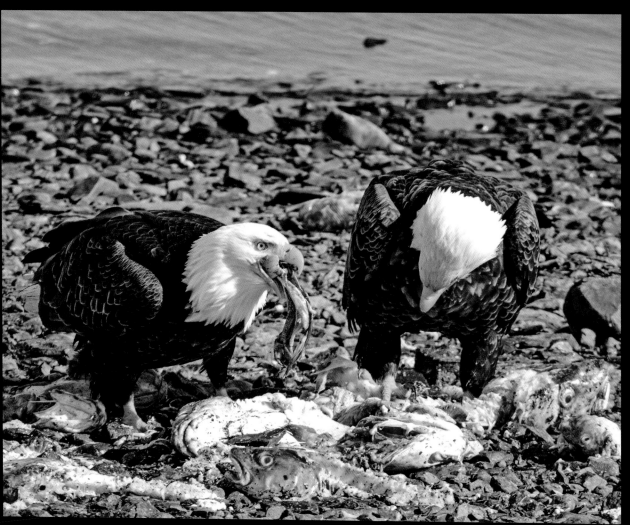

Bedding Areas, Trails, and More

Some other major things to study at home and look for in the field are bedding areas, the actual beds or nests themselves, travel routes and trails leading to and from bedding and feeding areas, places where trails intersect, parts of the actual animals (feathers, hair, etc.), territorial and dominance markings, preferred breeding areas, signs of sexual activity, bathing and drinking areas, etc. Along with doing all the reading and studying you can about these things, doing an image search on the Internet can help you get familiar with what fresh sign looks like for different species of wildlife.

A Word of Caution

Another word of caution: going right into an animal's home territory, especially its sleeping area, can be extremely dangerous! Here in Alaska, the majority of bear maulings occur when someone stumbles upon a sleeping bear in thick brush. Just as with humans, animals don't like it much when you mess with things like their family, food, and personal space—and they don't like being rudely awakened from a nap! Be respectful and extremely careful at all times, even if the animal you are pursuing is small and gentle. Mother Nature appreciates common courtesy just as much as anyone else; however, she may not always be as forgiving if one shows disrespect!

Once you learn what to look for and get a little practice under your belt, you will be able to recognize a great deal of animal sign and become fully aware of their immediate presence without going right into their personal space, such as bedding areas. Also, the more you learn

◀ **Top:** In dry areas, finding a watering hole can be even more important and productive than photographing near food sources.

◀ **Center and bottom:** This bear chair/bed and eagle's nest are obvious signs that those animals are present and active.

▲ Territorial markings, such as these bear and cougar scratching trees and whitetail buck rub, are other things to look for while scouting in the field.

▲ If seeking to photograph birds, look for feathers below potential roosting trees.

▲ Heavily used wildlife trails are very easy to spot. These are also great areas to focus on for finding and photographing animals.

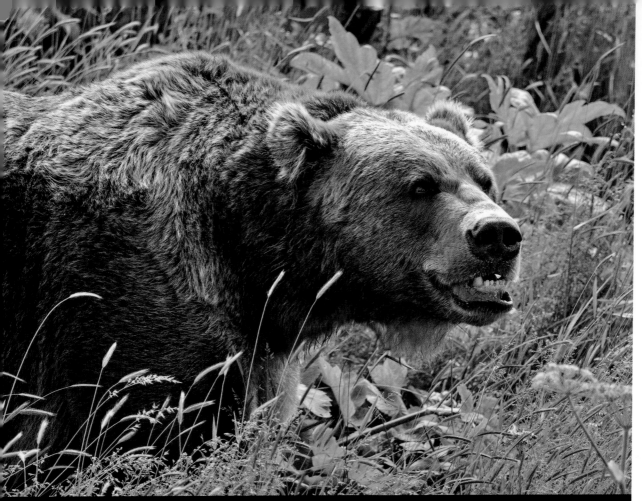

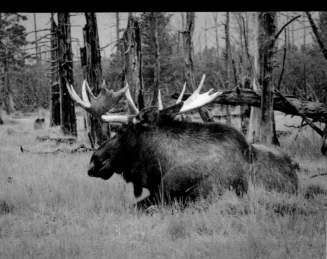

know good and well if you've been in their home turf, just as humans can easily detect if an intruder has been in theirs.

Surveillance

After you locate fresh evidence of an animal's presence, it's time to do a little surveillance.

Location Selection and Concealment

Pick out a couple of nearby locations where you have a good view of those prime areas,

to recognize an animal's personal zones and take a nonintrusive, hands-off approach, the greater your chance of not spooking the animal out of the area. Don't forget, most animals will

▶ When possible, find locations at higher elevations and with a broad field of view for wildlife surveillance.

make absolutely certain that you remain up-wind by constantly using your wind-checking device, and hunker down for a few hours at a time when the animals are likely to be active (such as the mornings and evenings). If you can't find an area with a significant amount of natural cover to keep you hidden, then it may be time to make use of your camouflaged gear and perhaps set up a ground blind or tree stand. Surveillance areas can be a fairly short distance away from a particular spot you want to have a better look at, or they may be from long range. If you are with a group of people, make it a point to safely split up (preferably in pairs) to watch multiple areas. Be aware, however, that the more people you have with you on a photo shoot, the more your chances of success go down, due to the increase of detectable human activity.

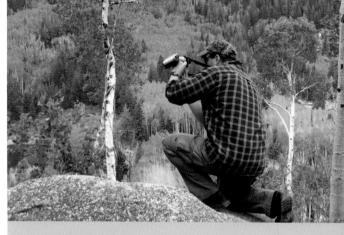

Trail Cameras

Another great way to cover more area when doing some pre-photography surveillance is to use a trail camera. A trail camera is a small, box-like unit that you set up in an area where there is a great deal of fresh sign. It then takes a photo anytime something walks in front of it. These are especially useful at pinpointing the exact times an animal is in an area that you

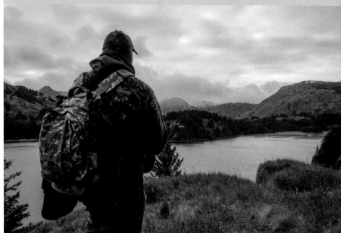

▼ Though I never managed to see or photograph this huge Kodiak bear in the daytime, I knew from using a trail camera that he was a frequent visitor at night.

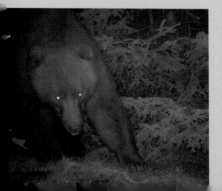
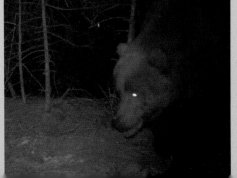
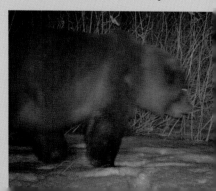

have not been able to personally watch—or when you simply don't want to take a chance at contaminating an area with human scent or sign.

No matter how you go about surveying potential hot-spots, the main objective is to visually confirm an animal's presence. A surveillance session gives you more detailed information about specific times and the best locations to set up in for a photo shoot. Once you consistently see an animal in a particular area, you can finally get ready for the long-anticipated photo shoot.

Be Respectful

Let me end this chapter with another word or two about safety. Along with studying animal sign and general behavior, it's also imperative to be familiar with signs of aggression and to be well aware of potentially dangerous situations you may enter into with a particular animal. Be safe! Wildlife photographers do get hurt and even killed from time to time while trying to get that shot of a lifetime. A few years ago, a man was killed by a grizzly bear in Denali Park—while apparently trying to photograph the animal at too close a range. Along with the photographer tragically losing his life, the bear also ended up being killed as a part of the investigation. That is usually the case in such circumstances. An important point to remember is that how you interact with wild animals not only dictates the outcome of the encounter for yourself, it also influences how that animal will react to future encounters with humans. An improper, unsafe encounter puts you, future people, and the animals themselves in potential danger.

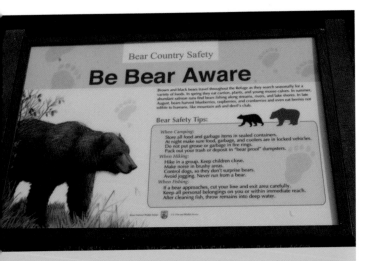

◀ **Top:** For your sake, and that of the animals you wish to photograph, be safe and respectful at all times!

◀ **Bottom:** While extreme, close-up images such as this can seem both frightening and disrespectfully close to some, the reality is something quite different. In photographing potentially dangerous animals I use a zoom lens of significant power, I maintain a safe distance, and whenever possible I make it a point to have a natural or man-made barrier between myself and the animal. Precautions such as these are an absolute necessity in keeping both you and the animal safe and comfortable.

7. Active and Passive Photo-Hunting

There are two primary modes of hunting: active and passive. Active hunting techniques are those in which one is actively seeking out and going to the animal by methods such as spot and stalk. Passive hunting, on the other hand, is basically a matter of utilizing still hunting or ambush techniques in which a photographer waits for the animal to come to him or her. While passive techniques are generally more ideal, both approaches have their proper places in photography. Choosing one method over another will depend greatly on the particular animal you seek to photograph, as well as the terrain.

▲ Searching for wildlife with one's eyes, by means of quality binoculars, is far more productive and efficient than searching on foot – especially when there is lots of ground to cover.

Spot and Stalk

The spot-and-stalk method of hunting/photography is more ideal for animals that have a large home range, are rather nomadic, or simply don't stay in one particular area for too long. Scouting and surveillance will confirm if an animal is using a particular area, but that area still may be quite vast and require the photographer to actively pursue the animal in order to successfully photograph it. A spot-and-stalk hunt may be a matter of carefully finding and following an animal around an area the size of a community park, or it might be a matter of being on the move for miles upon miles, through difficult terrain. Whatever the case, the photographer must be prepared for what the situation dictates.

Spotting

A good way to begin a spot-and-stalk hunt is to start at the areas you used for surveillance purposes, areas where an animal's presence and activity has been visually confirmed and where you have a good field of vision. After all, you

▲ Train your eyes to look for small parts, colors, or shapes of animals. Do you see the bear in this picture?

▲ How about now?

have to spot an animal before you can begin the stalk. Whether you sit, wait, and watch to achieve the initial spotting of an animal or spot it while slowly hiking around a prime area, a pair of quality binoculars (or a spotting scope for long-range purposes) is an important tool. It is much more productive to first hunt with one's eyes before hunting with one's legs.

When spotting, look for parts of an animal, such as a distinct color in a patch of weeds, the shape of an ear, tail, antler, face, etc. Quite often, an animal will not be standing out in the open somewhere just waiting for you. Most wildlife remain fairly hidden much of the time and stay close to cover. Animals that do inhabit wide-open terrain tend to position themselves in a manner that enables them to spot danger from far away. In either case, using binoculars, even at a very short range, can aid tremendously in penetrating visual obstacles and spotting the otherwise hidden details of an animal.

Slow *Waaaay* Down

While spot-and-stalk hunting is an active method of hunting, it is done at a very, very slow

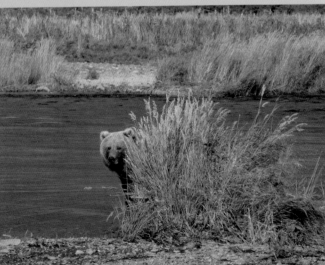

◀ **Top:** Learning to look for and recognize the slight subtleties in texture, movement, and tonal contrast of wildlife in their habitat greatly improves the chances for a successful photo outing. Would you have stopped to have a closer look at this patch of grass if just casually passing by?

◀ **Bottom:** Animals have an uncanny ability to blend into their environment and go completely unnoticed to the average human eye. Learning and practicing the ability to see "parts" of animals will open up a whole new world.

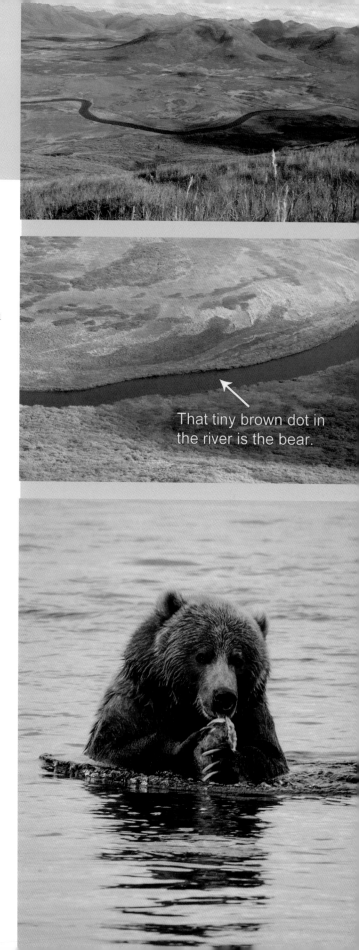

That tiny brown dot in the river is the bear.

pace. You should be moving slowly enough to visually examine all your surroundings, both with the naked eye and binoculars, carefully listening for the most subtle of movements in the area, consciously planning the next few steps you will take, and then slowly taking them. You are essentially moving in short sequences, step by step, yard by yard, stopping in areas that are close to cover, where you can remain as hidden as possible. At such a pace, it may seem like it would take hours to get to where you're going—and it *does* take a lot more time—but it's amazing what happens in the process.

When you slow down, *waaaaaay* down, a whole other world is revealed, which can be a huge source of gaining inspiration for other subjects to photograph in nature. When moving like a turtle, you begin to notice the slightest, most hidden of tell-tale animal sign. The pleasing, earthy scent of specific trees and plants becomes much more noticeable when you are not in a huge rush. In fact, if the wind is right, you can sometimes even smell the animal you are pursuing. Slowing down helps you discover how much life, big and small, is all around. You begin to appreciate the sound of the dew dripping off the leaves in the early morning breeze and the symphony of nature that often goes unnoticed when you're moving too fast. Purposely moving in slow motion while hunting/photographing, either actively or passively, enables you to focus intensely on

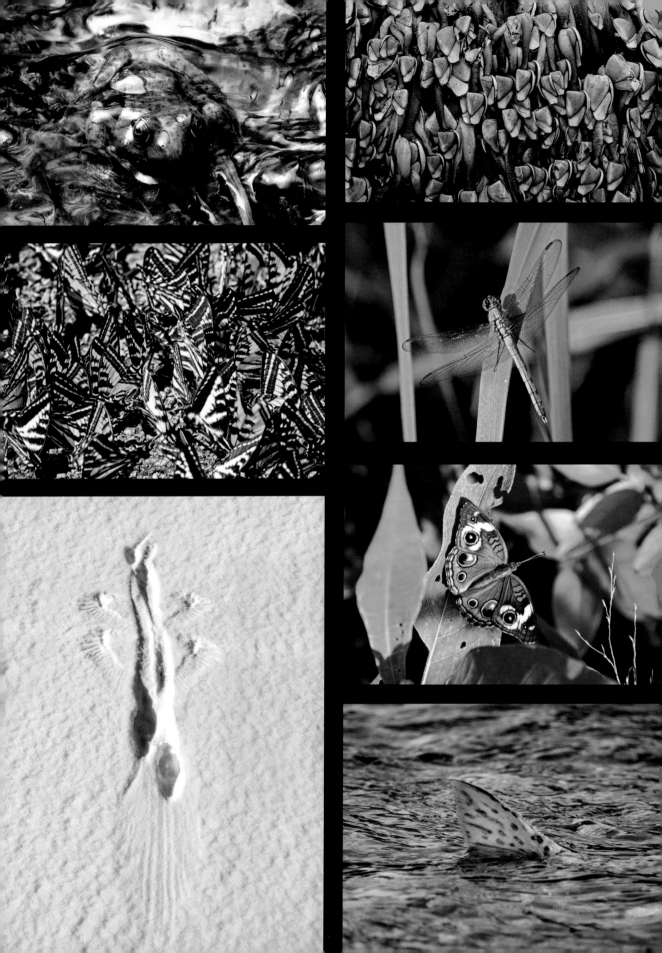

each and every detail of your surroundings in order to detect even the slightest twitch of an animal's ear, flick of a tail, or footstep. Your entire being becomes a super-sensitive alarm system. Your powers of concentration and focus are pushed to the max. The senses become hypersensitive. Sounds are not just heard, they are felt. They radiate throughout the entire body. Sights are not just seen, they draw a response from the depths of your soul. The fragrance of the forest becomes intoxicating and euphoric. The feeling of the wind, rain, or snow on your skin (in moderation) evokes a hypnotizing sensation. If you're not experiencing these phenomena, then you are still moving too fast. Slow down!

Movement and Sound

When spot-and-stalk hunting, it's important to note that the first things many animals notice (besides scent) are movement and sound. For example, if a whitetail deer sees or hears even the slightest unidentifiable commotion in the woods? You guessed it—gone in a flash! Likewise, the hunter/photographer must be constantly exercising that hypersensitive mode of awareness, seeking to detect the most subtle of sights and sounds of his target animal, while at the same time keeping his or her own movement and sound to an absolute minimum. While wearing quiet, camouflage clothing will help with this, you can also make it a point to "camouflage" your movement in order to successfully approach an animal. The wilderness can be a noisy place at times, with wind gusts, rustling leaves, bird and animal sounds, etc. A photographer can take great advantage of this by masking the sounds of his or her

◀▼ **Below and facing page:** Slowing way down while moving through the wilderness teaches you to recognize hidden beauty everywhere and creates even more photographic opportunities.

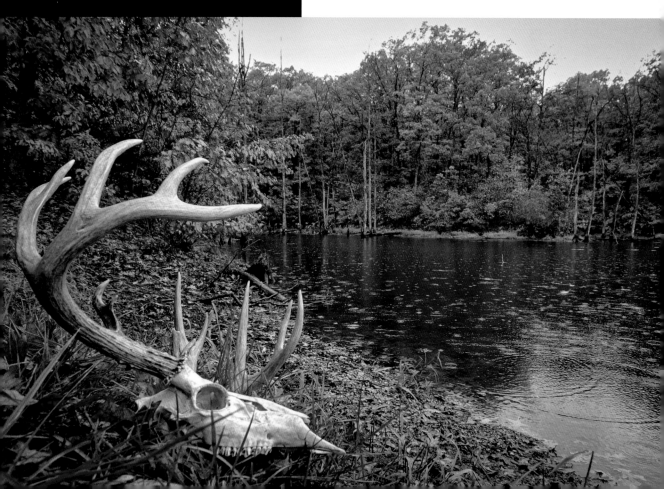

▲ If you have to move across noisy, open terrain while closing in on an animal, wait until the wind picks up or there is some other natural noise or commotion to camouflage your sound and movement.

movement with the noises of nature. For example, if you have to walk over a stretch of noisy rocks or gravel, wait until the wind picks up a bit or until there is some other form of natural auditory commotion—or use a non-alarming animal call of some kind to mask the sound of your movement.

Another tactic for camouflaging one's sound and movement while spot-and-stalk hunting is to walk like an animal. Human beings have a very distinct sound when they walk through the woods. Not much of anything in the wilderness sounds like we do— except maybe a Sasquatch! Walking more like a four-legged animal (making two well-defined sounds/steps with each foot, heel and toe) breaks up one's cadence and can having amazing results! I've walked right through areas of

bedded deer and roosted turkey without alarming them while using this "deer walk" method. Of course, the wind has to be right and you have to be either out of sight or well camouflaged for this tactic to be effective. So, again, don't forget to be constantly aware of what the wind is doing!

Closing the Distance

When you have finally gotten into photography range of an animal, you really have to be on your toes. Getting within a few extra yards or into an area with a less obstructed field of view can be tricky. After spending hours carefully stalking an animal, the last thing you want to do is get in a rush or get so excited that you blow it. So, relax! Take some deep breaths. Calm your mind and settle your nerves be-

fore taking those few last steps or getting into position to photograph. Go through a game plan in your mind as far as what, how, and where your final position will be. It may mean crawling on your belly, walking on your knees, or engaging in other guerrilla maneuvers to get in shooting position, so be ready for it. Closing the distance over those final few yards might be accomplished by using a call to bring the animal in just a little closer to you. Is your call handy? Is your camera gear ready for action and on the right settings? Go through a mental checklist before you get ready for the moment of truth. Don't forget that ever-important mantra: prior preparation prevents poor performance!

Still Hunting/Ambush

For those who may not be up for the challenge of spot-and-stalk hunting, or in situations where it may not be the most effective or productive means of photographing wildlife, the other (more popular) option is to utilize passive hunting techniques, commonly referred to as "still hunting" or "ambush" techniques. These tactics include the use of natural or man-made blinds, tree stands, or anything that will keep you well hidden while you sit and wait for an animal to show up at a specific, predetermined location. While this may seem like a lazy, easy way of hunting/photographing, in reality it is not. As previously covered, a lot of work and detailed scouting goes into finding those primary locations where an animal spends time. And sitting quietly in one little area, for hours or even days, in all kinds of nasty weather, often surrounded by hordes of insects, is certainly not an easy task! It can actually be much more demanding, both physically and mentally, than spot-and-stalk hunting.

The Right Location

As I mentioned earlier, the area that is chosen for surveillance purposes can, in many cases, be the perfect spot to "ambush" an animal with

▼ Walking more like a four-legged animal can be an effective way to camouflage your sound and keep creatures more at ease. Make two distinct sounds/steps with each foot and break up your cadence.

your camera. If an animal is spending a lot of time in that location, there is often no need to look any further. On the other hand, you may need to fine-tune your position to attain better visibility of the animal, get better lighting, have more cover for yourself and your gear, or to work more effectively with the primary wind direction to control human scent. Whatever the case, once you have that spot picked out, you can then go about the task of making it a custom-built, comfortable, productive, wildlife photography still-hunting zone.

Maximize Comfort

Whether your still-hunting zone is on an elevated grassy river bank near a salmon stream, up in a tall tree overlooking a bedding area, in a pile of dead-fallen trees along a heavily used trail, or burrowed in behind a pile of snow, you need to have a spot where you can be cozy and quiet for long periods of time, with all your

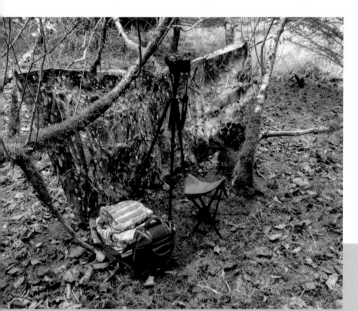

◀▼ Whether you are using natural cover or a man-made blind, keep your area organized and as comfortable as can be. You may be there for a long time.

gear hidden and readily accessible. If you will be sitting on a portable chair or stool behind a blind, or making use of a tree stand, make sure it is strong, supportive, and comfortable. Try it out and give it a test run before taking it to the field.

Minimize Sounds and Smells

As I mentioned earlier, try to use packs and gear bags that are quiet and don't have noisy zippers, Velcro, etc. Make an effort to silence everything you have with you in a still hunting area, from your camera and tripod to your lunch bags and water bottle. Clear out the leaves, rocks, sticks, and anything in your spot that could make noise if you have to move around. Also, keep your area as scent-free as possible. Don't take aromatic foods or beverages with you. If you have to go to the bathroom, go somewhere as far away from your still hunting area as you can. Again, have your essential gear set up and ready to go at all times. Fumbling around in your pack for an animal call, lens, or other item when you need it most can cost you the shot of a lifetime. Be ready for anything, at any moment. Expect the unexpected and be ready to capitalize on it.

Stay Alert

Your still-hunting area should become like a snug little nest, where you feel secure and fully prepared for your photography efforts. It should feel like home while you are in the field; in essence, it will be. However, and very importantly, don't get too cozy and comfortable. Don't forget, you are still on the hunt! The absolute, most important thing to do while still hunting is to keep your eyes open. I don't know how many times I've been out hunting with people over the years who used most of

Clear out noisy debris from your area

▲ Clear out leaves, twigs, or any debris from your area that may make noise while you are moving around. Silence is golden—especially with sensitive, wary wildlife.

their time in a tree stand or in a blind to take long naps, read lengthy books, or incessantly fiddle around with their cell phone, and then come back to camp without even having seen an animal. While being immersed in the beauty and solace of nature can certainly be relaxing and enjoyable, one has to stay focused on the task at hand to be successful. That means remaining alert, awake, and intensely fixated

on one's surroundings—constantly scanning the area and watching for the most subtle of movement or activity. Make it a point to keep distractions to a minimum by leaving distracting things at home or back at camp.

If boredom begins to set in, which it often does while still hunting for hours upon hours, I recommend fighting it off by engaging in activities that keep the mind busy, while the eyes and ears are focused on one's surroundings. I like to use the long hours and days in a blind or a tree stand to do something that most people don't have much time to do in our busy, hectic world: to simply think, pray, or meditate about life. Think about it. When is the last time you spent an entire day in relative silence, just thinking? While it may sound like a recipe for insanity to some, I find it incredibly therapeutic, healing, restorative, and productive. Photographers are, after all, creative people—and creative minds need quality time to think and create. So keep your mind busy and stay alert, but don't let your visual or auditory guard down for even a second!

Use Your Ears

Speaking of one's "auditory guard," using one's ears with the same degree of intensity as one's eyes is equally important, and while it can be made even more effective with the use of hearing-amplification devices, don't try to rely primarily on sound to detect approaching wildlife. Many animals simply don't make a peep while moving through the woods, especially if they are relaxed and are often pausing to feed or rest. I've had whitetail deer walk right below me while in a tree stand and bears, moose, turkeys, and other creatures magically appear out of nowhere without making a sound. I never would have known they were there if I were not paying attention. So again, I can't stress enough how important it is to keep your eyes open at all times, and to be constantly scanning the area.

Calls and Decoys

Another thing you can actively do while engaging in the more passive methods of still hunting is implementing calling and/or decoying techniques. Using animal calls, and adding an extra element of realism and visual attraction with a decoy, can be very productive at bringing wildlife out of hiding and into camera range. Along with calls and decoys, using those attractor scents that I covered earlier can also have major drawing power.

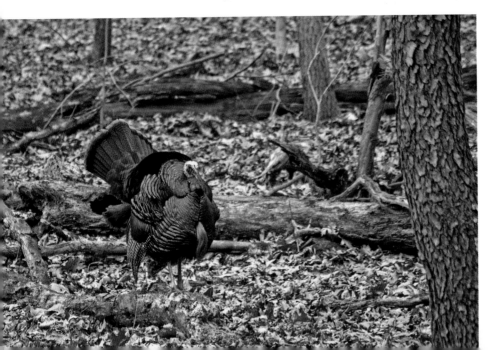

◄ Wild turkey respond very well to calling techniques.

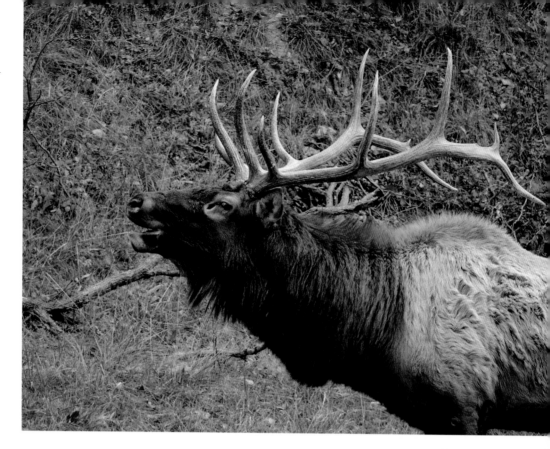

► Making calls that sound like a subdominant animal is an effective technique for getting the more dominant ones, such as this huge bull elk, to respond.

Let me also stress again, however, that these techniques and tools should be used in a legal, limited, respectful, non-harassing manner. The goal of using calling techniques for photography purposes is simply to get an animal a little curious and a little closer into camera range, not to fool it to the point of radically altering its behavior—as is often done in true hunting situations in which an animal will ultimately become food, instead of a photograph. The sounds, sights, and scents to use for calling purposes will, of course, depend on the animal you are trying to attract. Again, this is where all the pre-field study comes into play.

An easy reference for calling strategies and scenarios to implement is to make use of the traditional "seven deadly sins" of Christianity. These seven vices that often negatively influence the hearts and actions of humans also come into play in the animal world. In case you

have forgotten what they are, the seven deadly sins are: lust, greed, gluttony, envy, anger, pride, and sloth. Let me say a few things about each one in regard to calling techniques.

Lust. Calls that imitate mating vocalizations, sexual activity, rival animals fighting over breeding rights, etc. Example: The gobbling of a wild turkey.

Greed and Envy. Calls that imitate a subdominant animal feeding or breeding in an area where there is evidence of a more dominant animal's presence. Example: The sound of a small bull elk bugling in an area where the dominant bull is nearby with his harem of cows.

Gluttony. Calls that imitate active, aggressive feeding, sounds of animals that are food/prey for others, distress sounds that imitate an animal being eaten. Example: The high-pitched squealing of a rabbit being eaten by a fox or hawk.

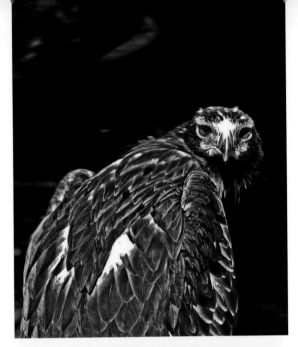

◀ **Top:** Birds of prey and other predatory animals respond very well to distress calls.

◀ **Bottom:** Antler-rattling calls and devices that imitate the sound of fighting deer or elk often attract others of their kind who want in on the action.

Anger. Calls that imitate aggression, fighting, or the sound of an intruding animal. Example: The clashing and rattling of antlers of whitetail bucks in a fight or sparring match.

Pride. Calls that imitate those of dominant animals. Example: The low, powerful grunts of a dominant bull moose.

Sloth. Calls that imitate resting, relaxed, soon-to-be sleeping animals. Example: Wild turkeys flying down from a roosting tree in the morning or up into the tree in the evening.

As seen in these examples, many of these "seven deadly sins" calling techniques can be applied to more than one situation. For exam-ple, feeding and breeding sounds can be used to evoke not just a hunger or sexual response, but also one of greed and envy. Let me share a quick story with you and better elaborate on the matter. During a turkey hunt a few years back, I spent all morning trying to call in a big, dominant tom (male turkey). He would come in to within 75 yards or so of me, stay way back in the thick brush, and gobble like crazy—but not budge! No matter what I did, he just would not come any closer. This was to be expected, as the natural order of things is for the hen turkey (whose calls I was imitating) to go to the tom when he gobbles, and since the hen he was hearing (me) was not showing up, he stayed put. Finally, after several failed attempts to bring the tom closer, I changed tactics and began scratching around in the leaves and dirt while making feeding calls. That did it! That big ol' tom turkey came right in to see what other turkey would dare intrude on him and eat up all that good food. Appealing to his sense of lust was not working, so I began to work on his sense of gluttony and greed. As a result, I had a nice bird to eat and share with my family for Thanksgiving dinner that year.

Final Thoughts

To wrap things up a bit here, whether you are using active or passive hunting techniques, I want to again stress the importance of doing so knowledgeably, safely, respectfully, and legally. All of the approaches I covered in this chapter are subjects to explore, study, and practice more in depth before implementing them in

▲ Sounding like the king of the forest is a sure way to get the attention of lesser-ranked animals.

▶ You can successfully locate, call in, or even influence an animal to stay put by sounding like another of its kind that is relaxed or bedded.

the field. And as a final word of advice: no matter what methods or tools you may apply, make a detailed plan for each photo shoot. Write down the specific goals you wish to accomplish for a particular day, how you plan to accomplish those goals, what techniques and strategies you plan on using, etc. At the end of the day, write a review of how things went, what camera settings you used, how you can improve, etc. Keeping a detailed field notebook and recording your goals, tactics, reviews, and observations is a major recipe for success and continued growth as a wildlife photographer.

8. The Moment of Truth

The ultimate purpose of all the preparations discussed so far is to finally press the shutter button and capture unforgettable images. In the world of hunting, this point of culmination—when all the preparation, practice, time, energy, and effort come together in the pulling of the trigger or releasing of an arrow—is referred to as the "moment of truth." It is a self-revealing, self-judging moment that does indeed manifest the truth of one's constitution as a hunter. Success or failure comes in a split second, and there is no denying the outcome. It is final.

> 66 You will either capture a great photograph, technically and artistically, or you will have an image file ready for deletion. 99

The same phenomenon holds true in wildlife photography. When all the study, preparation, travel, and in-the-field effort climax at the moment of having a magnificent wild animal in focus and the camera's shutter about to be deployed, the outcome will be verified in a fraction of a second. You will either capture a great photograph, technically and artistically, or you will have an image file ready for deletion . . . and an experience that can never be re-created for a second chance. You simply have to be ready to shoot accurately and proficiently in the same manner that a well-trained marksman uses to confidently and consistently hit the bull's-eye of his target.

The Right Tools

The specific, technical aspects of camera functions and photographic composition are the subjects of entire books. They are far too detailed and important to try to cover in a single chapter. I, again, encourage you to study all you can, to learn how to apply those technical and artistic principles, and then to practice, practice, practice. For now, however, I'd like to offer a simple overview of the essential tools for actually shooting wildlife with a camera.

Camera

First of all, you obviously need a camera that is suited to wildlife photography, and that means a DSLR that is fairly weather-resistant, very rugged, capable of taking lots and lots of pictures at fast speeds, and able to process those pictures quickly. You also want a camera with superior low-light capabilities. Do some research and side-by-side comparisons of cameras that are in your price range and read lots of reviews from people who have used them. Also, unless you are shopping online, get your hands on a camera you are interested in. You

are going to be spending lots of time with it, so make sure it feels good, fits your hands well, and that its function buttons are easy to find and operate.

Lenses

A high-quality zoom/telephoto lens will be necessary for a great deal of wildlife photography. The material I covered in this book thus far will definitely help you locate and get relatively close to wild animals, but you should still strive to maintain a healthy, safe, respectful distance. And, in many cases, you simply can't get up-close shots of animals without a long lens.

▶ ▼ I waited all week to see this Kodiak bear stand up on the one and only boulder along this particular stretch of river. Being at the ready and anticipating his movements finally paid off.

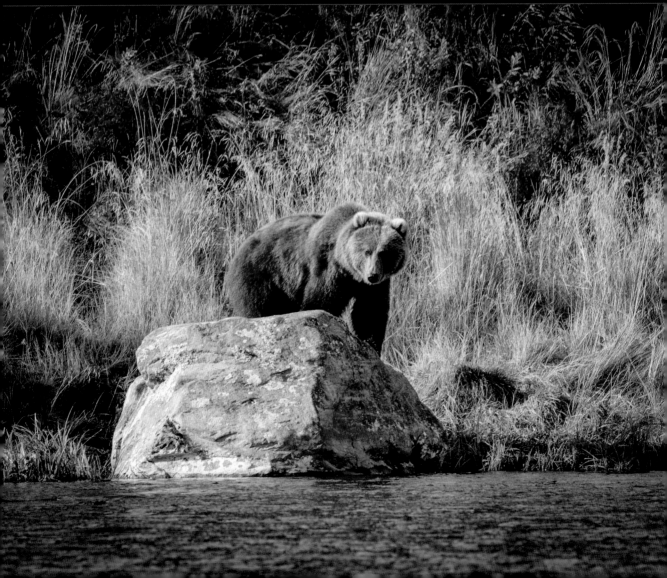

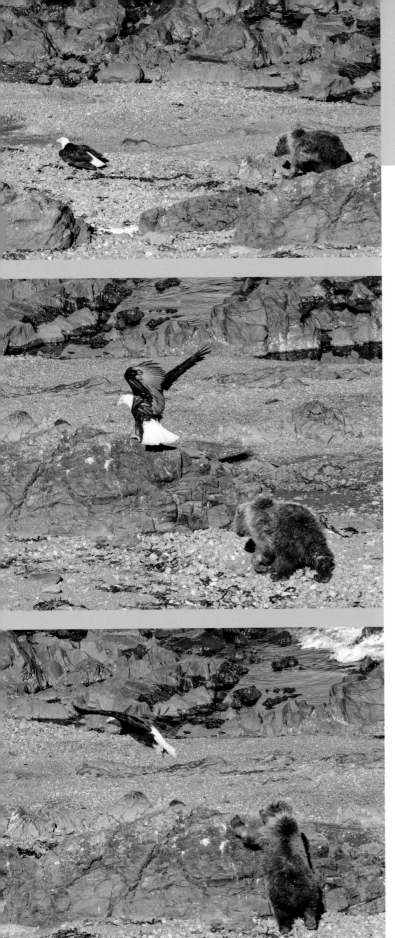

Camera lenses are certainly not cheap, and the longer the lens, the more expensive it will be. For starters, as a bare minimum for zoom/telephoto purposes, I recommend a 300mm lens. Keep in mind, too, that wide-angle shots of animals enjoying their habitat are much sought after, so have a lens that is more suitable for landscapes in your bag as well. There are, naturally, lots of options out there as far as makes and models of lenses. Again, I recommend reading some reviews, talking to other photographers, and making sure a particular lens you may be interested in is compatible with and well-suited to your camera.

Tripod/Monopod

A tripod or monopod that you can operate quickly and quietly is another essential tool of the trade. While you can certainly get good images while shooting freehanded in some situations, having your camera firmly mounted on something stable and secure will increase the quality of your work quite dramatically, especially in low-light settings.

Memory Cards

Having several high-capacity memory cards for your camera is another

important consideration. While a hunter strives to take an animal with one shot, a photographer needs to be ready to take hundreds of shots on a photo shoot. Get high-quality cards, keep them readily accessible in the field, and protect them with your life from the elements.

Anticipate the Shot

Perhaps the most important part of photographing a wild animal and making the most of that moment of truth is learning to anticipate the shot. This is where lots of time spent just watching and studying wildlife really pays off. The more familiar you get with the movements and behavior of a creature, the more you will be able to consciously capture that perfect shot.

Preparation and Readiness

When setting up in a blind, tree stand, or any place where you will be shooting from, make it a conscious point to pick out features in the landscape that would make great compositional elements for a photograph and be ready to shoot at a moment's notice. Have your camera and tripod at the ready, facing in the right direction, at the right height, pre-focused on the exact area you intend to photograph the animal. Try to get in sync with an animal's movements, anticipating what it will do, where it will go, etc. Get in the animal's mind, so to speak. Strive to develop an instinct about the animal's actions to the point that you can simply know what is going to happen before it actually does and can photograph it with ease.

Use Firearm Shooting Techniques

Something else that can be of great benefit to taking the shot is applying firearm shooting techniques to controlling and triggering your camera. Doing so helps to train the eye, body, and trigger finger to work together and better judge distance, perception, and movement. The military has long taught recruits four fundamentals of marksmanship as a part of their rifle training. Those fundamentals are: steady positioning, proper aim, breath control, and trigger squeeze. Let's have a look at them in regard to their application for wildlife photography purposes.

> " Pick out features in the landscape that would make great compositional elements for a photograph. "

Steady Positioning. Have the camera firmly secured on a tripod, monopod, or resting on some other object (such as a stump, tree trunk, large rock, etc.). If shooting freehand, try to do so in a manner in which your elbows are anchored on the ground, your knees, or your abdominal area. Try to maintain as many points of bodily contact as possible in order to steady the camera if shooting without an anchored, stationary rest such as a tripod.

Proper Aim. Focus and stay on target with the camera at all times. If manually focusing on a subject, be able to do so quickly and steadily. Likewise, if using an auto-focus mode, be able to switch modes and make adjustments quickly. If using a tripod or monopod, be able to operate it in a manner in which you can remain on the subject and stay relatively focused. Here's a tip: I often keep the swivel head of my tripod a little loose so I can quickly move the camera around while still keeping it stable and well supported.

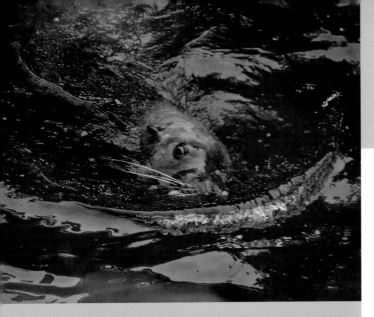

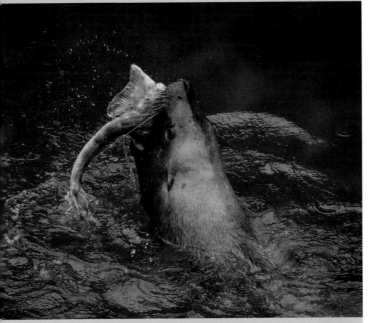

◀▶ **Left and facing page:** Sea lions may look calm, slow, and cute while floating around aimlessly or resting on a beach, but when it's time to eat – look out! Again, being aware of such aggressive feeding behavior was a key factor in anticipating this series of shots.

Breath Control. You'll be amazed at how controlling your breathing will increase stability while photographing a subject, resulting in shaper images. A basic breath-control technique that is used in shooting a firearm, which works equally well for shooting a camera, is as follows:

1. Take a deep breath before the shot and hold the breath while settling in on the target/subject.
2. Release half of the breath before pulling the trigger/shutter.
3. Pause, holding the second half of the breath, and take the shot/shots.
4. Release the second half of the breath during the follow-through after the shot.

A quick word about the follow-through after the actual shot: stay steady, still, and focused on your subject instead of instantly getting out of the shooting position to check out the image or to get ready for the next shot. Following through after each shot, or series of fast shots, will help develop good, solid shooting habits and crisp, sharp images.

Trigger Squeeze. Methodically pressing the camera's shutter button in a gentle, careful manner is just as important as doing so with the trigger of a rifle. Sudden, aggressive, or hard deployment of the shutter can shake the camera and throw the subject

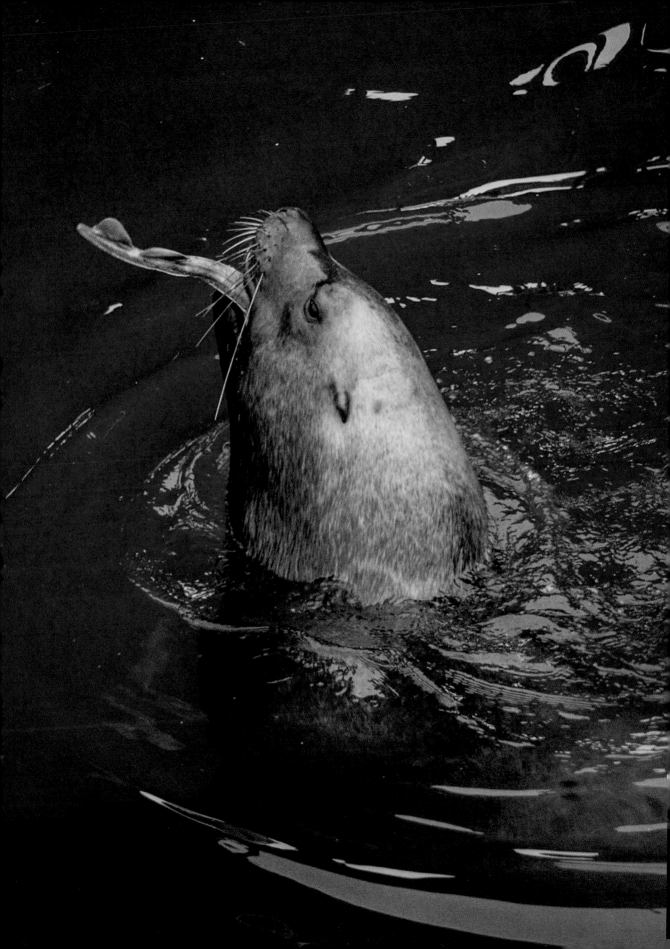

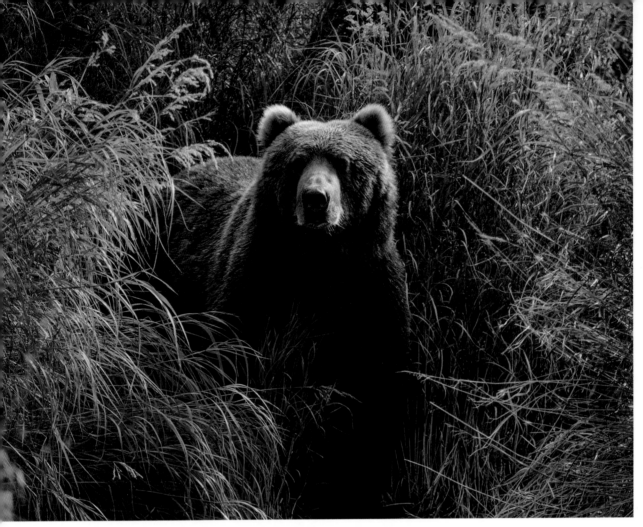

▲ Your skillful, critical eye is more important to making great images than any piece of gear you could buy.

out of focus, either a little or a lot, resulting in poor image quality. If you have a tendency to be heavy handed, or if you are going to be blazing away during a photo session and taking lots of shots in rapid-fire succession, it may be highly beneficial to use an external shutter release button to minimize camera shake and keep the subject in focus.

Final Thoughts

As with anything else in the world of photography, practice makes perfect. Learning to anticipate the shot and applying the fundamentals of proper shooting technique to your wildlife photography will pay off and produce great results—if practiced regularly and consistently. In time, these techniques become automatic. As a final word of encouragement, never forget that having expensive, fancy camera gear does not make one a great wildlife photographer. Training your eye to recognize beauty, even in difficult places and scenarios, learning about nature, spending quality time observing wildlife, having patience, and possessing the knowledge and disciplined skill to use the gear you have—no matter how simple—is what makes a great photographer. This is what matters most in the moment of truth.

9. After the Shot

You've spent time studying and researching the animal and the habitat you've dreamed of photographing. You've learned the technical and artistic fundamentals of photography. You've come to know your particular camera and photography gear inside and out and have practiced diligently with it. You successfully prepared for and traveled to a beautiful, wild land. You put in the time scouting and have been able to locate the animal you wish to photograph. You were able to safely, respectfully carry out a photo shoot of the animal, and you have a memory card loaded with potentially spectacular images that you've waited and planned so long and hard to achieve. Now what?

Be Respectful

If you are like a lot of not-so-well-trained, would-be wildlife photographers, you jump up from behind your blind or burst out of the bushes to scare the animal away so you can rush back to camp and check out the results of your photo shoot. Then you half-heartedly break down camp, leave trash lying around, get packed up, and head home. Obviously, these are not the correct actions to take. The same degree of intense preparation, patience, care, safety, and respect that goes into one's preceding efforts at making a wildlife photography adventure a reality should also be applied afterward.

Remain Undetected

First and foremost, after you have finished photographing a wild animal—especially if you have done so in an undetected manner—you should make every effort to *remain* undetected until the animal leaves the area on its own, undisturbed. While this may take a while and you may need to be very patient, doing so helps to ensure that a particular area can be used again for another photo shoot, if need be.

> **❝ You should make every effort to remain undetected until the animal leaves the area on its own. ❞**

Far more importantly, remaining undetected ensures that the animal will not alter its behavior due to human presence. Animals that are pressured too much or greatly disturbed in their primary habitat will often move out of the area, which could result in them not getting the proper food they need, becoming more susceptible to predation, etc. Nobody likes to have their privacy or their home rudely invaded or disturbed. If someone broke in and ransacked your home, or a stranger jumped out of the closet while you were enjoying a romantic meal with your spouse, you'd be pretty dang upset! The same applies to wild animals

and the places they call home. A photographer must make every possible effort to keep his or her presence as unnoticeable as possible—before, during, and after the photo shoot.

Leave No Trace

Along with being respectful of wildlife during your photography efforts, make it a top priority to practice a leave-no-trace policy while camping and spending time in nature. There is nothing more disturbing and disgusting than having ventured into an area of pristine, stunning wilderness, only to find beer cans, cigarette butts, food wrappers, toilet paper, etc. Cleaning up after yourself (and others, if need be) before heading back to civilization is a respect that simply must be shown to Mother Nature to keep her beautiful and clean.

▼ Finding trash in areas of otherwise pristine nature is disgusting! Make it a personal practice to leave the wilderness in better shape than you found it.

▶ **Facing page:** Images like the steam coming out of this squawking seagull's mouth, or the mist of water being shaken off the back of a bathing bear, are ones that happen in a split second. Shooting fast, multiple exposures of a subject can produce great results.

There are seven principles in regard to practicing a leave-no-trace methodology as outlined by the official Leave No Trace Center for Outdoor Ethics. They are as follows:

1. Plan ahead and prepare.
2. Travel and camp on durable surfaces.
3. Dispose of waste properly.
4. Leave what you find.
5. Minimize campfire impacts.
6. Respect wildlife.
7. Be considerate of other visitors.

The member-driven Leave No Trace Center for Outdoor Ethics teaches people how to enjoy the outdoors responsibly. This copyrighted information has been included with permission from the organization. For more information and specific details about each one of these principles, please visit www.LNT.org.

Processing Suggestions

Getting back home, regrouping from a photo shoot, and beginning to organize and process images can be just as daunting of a task as all the pre-field study and preparations. When I get home from a single-day photo shoot, I will usually have several hundred images on a memory card. If the photo shoot was a week-long adventure (or more), I'll have several memory cards full and possibly thousands of images to go through! And when it's all said and done, I'll have about a dozen really good, top-quality, superb photographs that will make the cut from the hundreds I actually shot. With digital

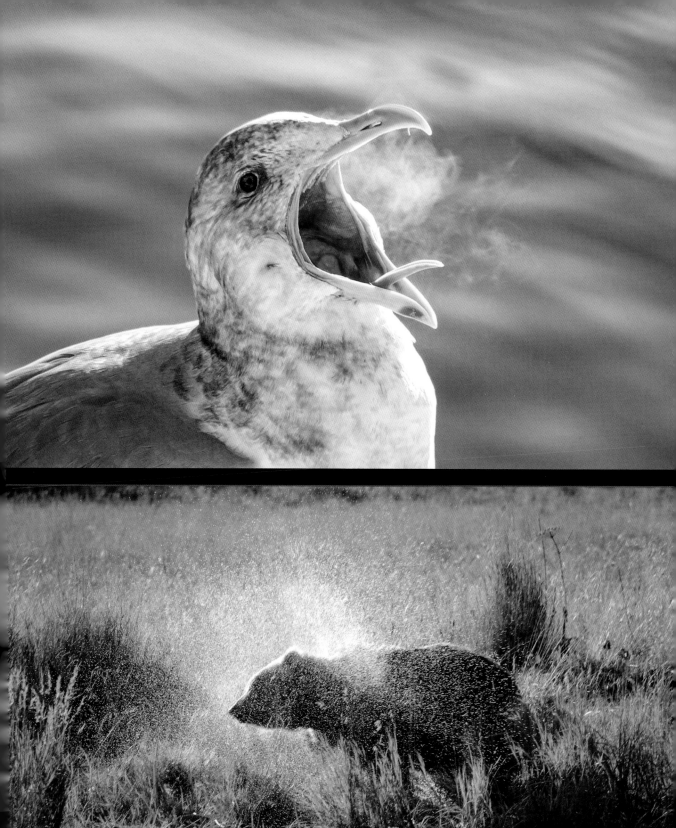

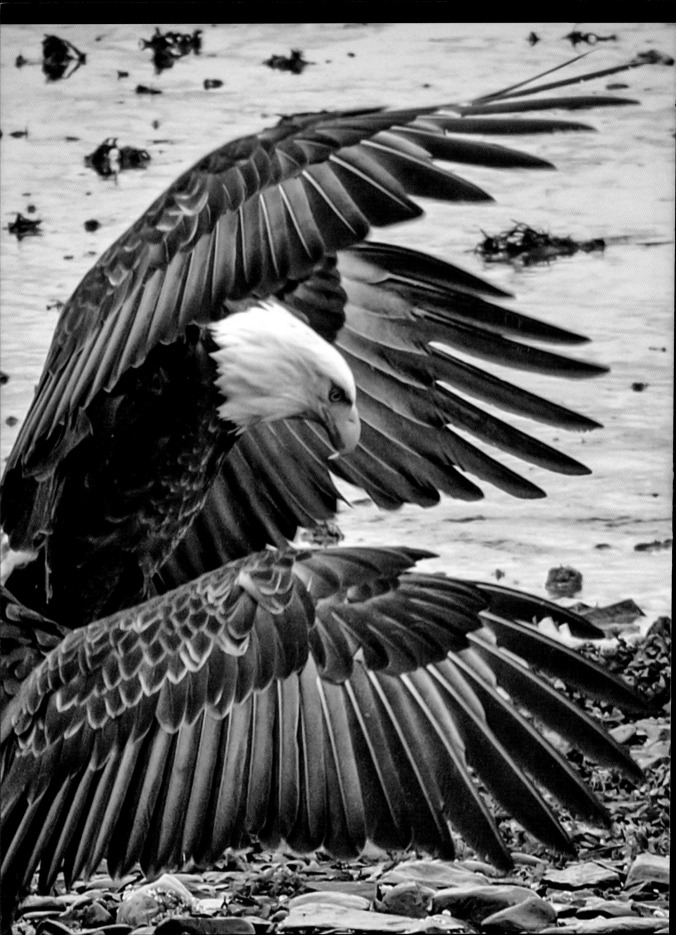

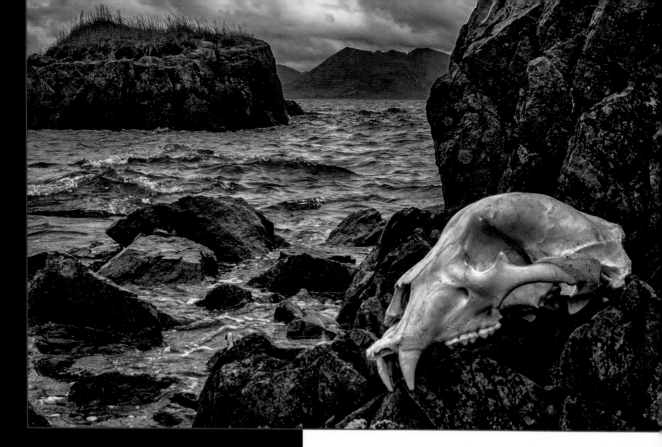

photography, there is simply no reason to be stingy. Shoot all you possibly can in the field. Those split-second moments that a camera can record, that the human eye misses, are often the real gems!

Rough Edits

So where to begin with all the post-processing work? I'll share with you my routine, as a suggestion to help you develop your own method.

I first view all the RAW files in a software program such as Lightroom or Photoshop. The initial step is to simply delete all the images that are out of focus or just plain bad in one way or another. Getting rid of all the *bad*

shots will most likely cut down significantly on what you have left to work with. After that first go-round, I'll step away for a while to rest the eyes, get a fresh perspective, and then come back and go through the files again, this time in a more refined manner, and I'll get rid of images that don't have serious potential for a finished photograph. I make sure a "keeper" file has good composition, lighting, sharpness, etc. While some of these elements can be tweaked later with a good software program, I only keep images that don't need too much work.

Cropping

After the second round of narrowing files down, I again give it a break for a few hours—or even wait a day or two in order to get a fresh perspective. Next, I'll crop my "keeper" images to get a better idea of how they may

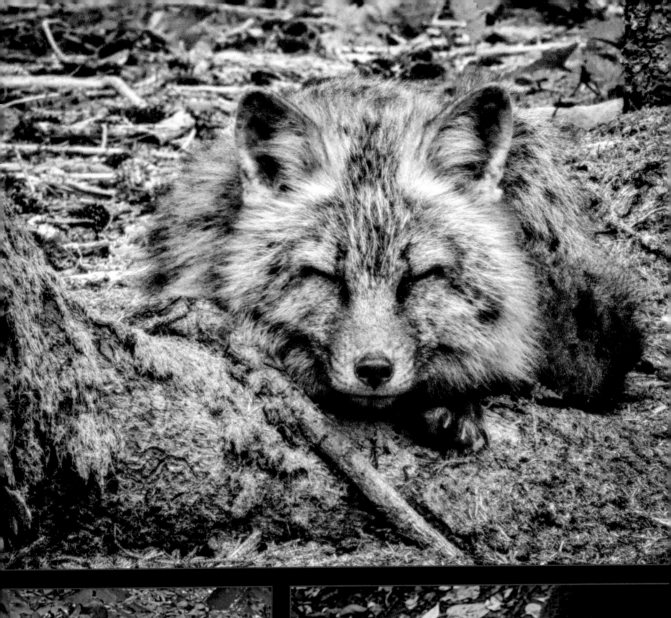

look more developed as a potential finished product. If an image sort of loses its appeal or compositional quality after being cropped, I toss it. Once more, this cuts down on the material to work with and keeps the refining process going.

Objective Edits

Once I have my hundreds of files narrowed down significantly to only those that are of the best quality and show true potential, I take a longer break (usually several days) before the next step. I do this in order to quell the emotional attachment I may have to particular images and keep things moving forward as objectively as possible. There are sometimes images that are *good* but not *great*—yet you may be tempted to keep them simply because the moment is so memorable to you. In such situations, I may keep the file in a different folder somewhere for nostalgia's sake, but I will delete it out of the batch of images from which I'm trying to produce the best-possible work. This is a hard but necessary step to take.

Refine the Serious Contenders

When I finally have all my images narrowed down to the serious contenders, I then begin the more detailed work of making adjustments to the lighting, color saturation, clarity, contrast, etc., of each individual image. I also experiment with making color images into black & white ones, adapting HDR (high dynamic range) techniques to certain photographs, and playing around with different processing techniques. Sometimes, an image that does not

look all that great in color can make a fantastic black & white image (and vice versa). Or, an image that needs a little extra "pop" might benefit from HDR. As a final step, I add a title, caption, keywords, metadata, and copyright information to each image, which not only helps to keep your images organized for yourself, but also makes them more marketable for professional use.

Much of what you choose to do as far as specific processing and photo-editing procedures will depend on the style of image you are ultimately trying to produce. There are those who seek to produce photographs that are purely of a documentary nature, trying to reproduce an image exactly how it was seen and experienced by the naked eye. Others may wish to produce an image that has more of an artistic flair to it, to manipulate colors, lighting, contrast, compositional elements, etc., to evoke a particular emotional response. Both approaches have their place, as long as the images are produced with honesty and integrity.

> " I do this in order to quell the emotional attachment I may have to particular images and keep things moving forward as objectively as possible. "

Wrapping Things Up

All good things must come to an end, and such is the case with this book. It is my sincere hope that the material I have shared throughout these pages will help you more thoroughly prepare and plan for your next wildlife photography adventure—whether it's just another assignment, or a once-in-a-life-time, long-dreamed-of trip.

As we have seen, there are many things to consider before being able to successfully venture into wild places and capture images of wildlife. Many of the important preparations and skills required to succeed have nothing to

66 As we have seen, there are many things to consider before being able to successfully venture into wild places and capture images of wildlife. 99

▼▶ **Below and facing page:** Wishing you the best of what awaits you with each new day! Good luck and good shooting!

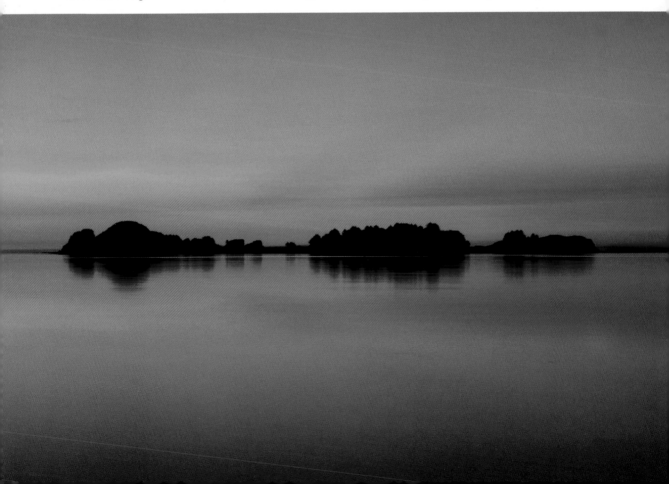

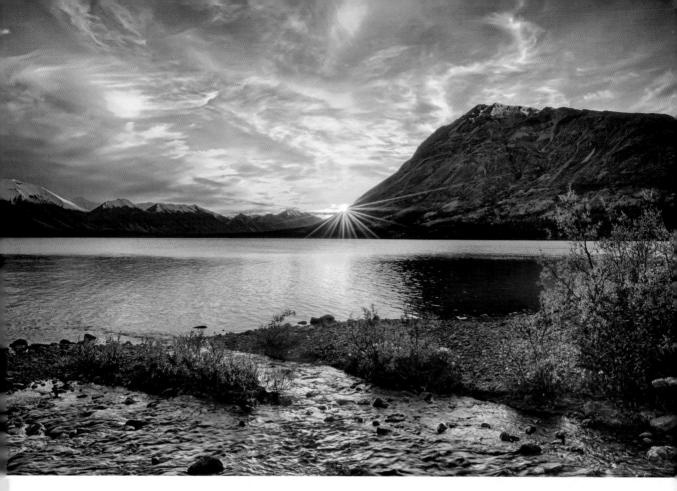

do with the more technical aspects of operating a sophisticated camera or being well-schooled in the latest photography software programs.

As I pointed out at the start of this book, while having a working knowledge of those things is a necessary prerequisite, becoming a successful wildlife photographer is more so a matter of developing a passion for wild places and the wild creatures who live there. It's through knowledge, patience, diligent preparation, respect, quality time, and practiced skill that one evolves from a mere observer of the natural world to a genuine, active participant in it. These are the things I hope I've successfully shared with you. These are the things I hope you share with others. And these are the things that I guarantee will make you a more advanced wildlife photographer.

Finally, if you'd like to view my entire body of photographic work, see what new adventures I've been embarking upon, ask questions, or order prints of your favorite images, please stop by my website: www.wildrevelation.com.

> 66 These are the things that I guarantee will make you a more advanced wildlife photographer. 99

Index

OTHER BOOKS FROM
Amherst Media®

Tiny Worlds

Create exquisitely beautiful macro photography images that burst with color and detail. Charles Needle's approach will open new doors for creative exploration. *$27.95 list, 7.5x10, 128p, 200 color images, order no. 2045.*

Magic Light and the Dynamic Landscape

Jeanine Leech helps you produce outstanding images of any scene, using time of day, weather, composition, and more. *$27.95 list, 7.5x10, 128p, 300 color images, order no. 2022.*

Professional HDR Photography

Mark Chen shows how to achieve brilliant detail and color with high dynamic range shooting and post-production. *$27.95 list, 7.5x10, 128p, 250 color images, order no. 1994.*

Photographing Dogs

Lara Blair presents strategies for building a thriving dog portraiture studio. You'll learn to attract clients and work with canines in the studio and on location. *$29.95 list, 7.5x10, 160p, 276 color images, order no. 1977.*

Painting with Light

Eric Curry shows you how to identify optimal scenes and subjects and choose the best light-painting sources for the shape and texture of the surface you're lighting. $29.95 list, 7.5x10, 160p, 275 color images, index, order no. 1968.

Advanced Underwater Photography

Larry Gates shows you how to take your underwater photography to the next level and care for your equipment. *$34.95 list, 8.5x11, 128p, 225 color images, index, order no. 1951.*

FLASH TECHNIQUES FOR
Macro and Close-up Photography

Rod and Robin Deutschmann teach you the skills you need to create beautifully lit images that transcend our daily vision of the world. *$34.95 list, 8.5x11, 128p, 300 color images, index, order no. 1938.*

DOUG BOX'S
Available Light Photography

Popular photo-educator Doug Box shows you how to capture (and refine) the simple beauty of available light—indoors and out. *$29.95 list, 7.5x10, 160p, 240 color images, order no. 1964.*

Legal Handbook for Photographers, *3rd ed.*

Acclaimed intellectual-property attorney Bert Krages shows you how to protect your rights when creating and selling your work. *$29.95 list, 7.5x10, 160p, 110 color images, order no. 1965.*